IMAGES
of America

WELLS

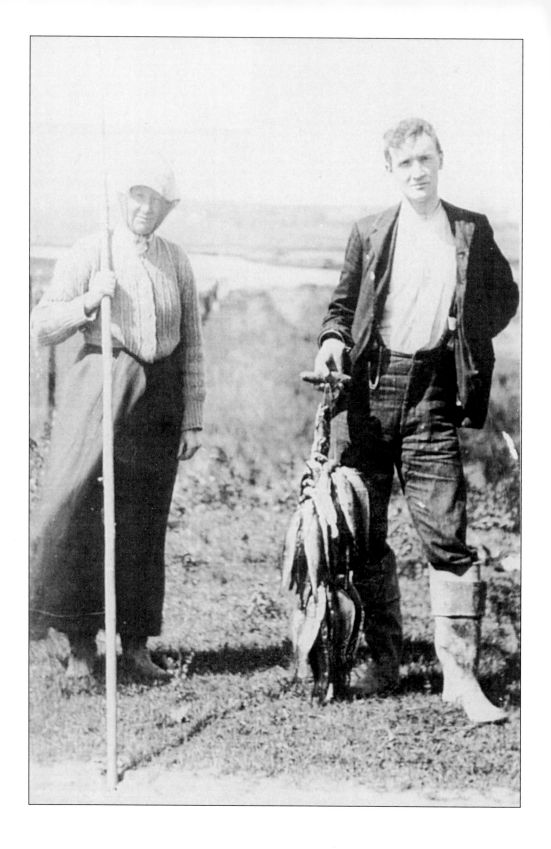

IMAGES
of America

WELLS

Hope M. Shelley

ARCADIA
PUBLISHING

Published by Arcadia Publishing
Charleston SC, Chicago IL, Portsmouth NH, San Francisco CA

Printed in the United States of America

Library of Congress Catalog Card Number: 2003107165

For all general information contact Arcadia Publishing at:
Telephone 843-853-2070
Fax 843-853-0044
E-mail sales@arcadiapublishing.com
For customer service and orders:
Toll-Free 1-888-313-2665

Visit us on the Internet at www.arcadiapublishing.com

Dedicated to the families of Wells

Contents

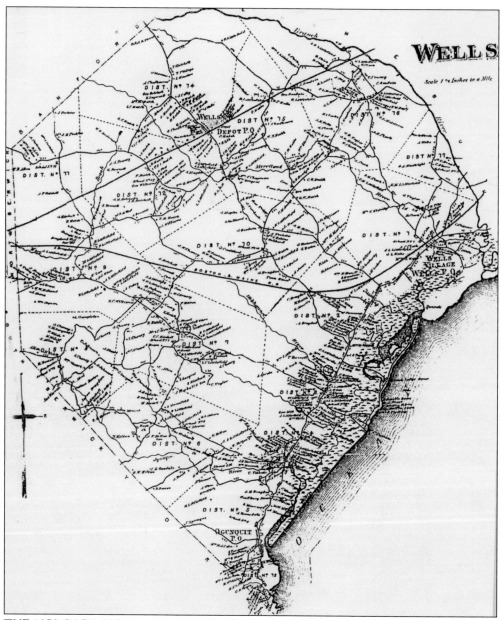

THE 1872 CADASTRAL MAP OF WELLS. This map features the seventeen school districts and the surnames of the landowners. Note the cluster of homes around the rivers and streams in each district.

Introduction

For more than three centuries the residents of Wells have nurtured their families by farming both the waves of the Atlantic and the furrows of the so-called "barren land of Wells."

Long before Wells' incorporation in 1653 as the third town in Maine, temporary residences were built on the beaches by traders and fishermen. Edmund Littlefield, the father of Wells, established a permanent home, sawmill, and gristmill as early as 1640–41 at the falls of the Webhannet River. Today this is the site of the Webhannet Falls Park at Buffum's Hill.

Reverend John Wheelwright soon followed and by 1642 was attempting to provide religious freedom here for himself and his followers. He established the first church and purchased several tracts of land for himself. During his brief three or four-year stay, he also served as an agent appointed to survey and allot lands.

The Indian Wars, from 1675 until the mid-1700s, made existence in Wells almost beyond human endurance. The noble men and women who remained were forced to withstand many terrors and adversities. They were murdered, their homes burned, and their farms laid waste. The Indians devastated all the territory northeast of Wells, leaving Wells the frontier town. The inhabitants were compelled to breast the full fury of the French and Indian forces. One of the most significant battles took place in 1692 near the site of the Garrison House on Post Road. This battle fulfilled an earlier prophesy: "Berwick, Kittery, York shall fall, Wells shall stand to see it all."

The staunch settlers rebuilt. Having survived poverty and disease, they were again called to fight. During the Revolution Wells contributed extensively to the army. At one time at least one-third of all able-bodied men were in the service. No other town in York County furnished a greater number of officers!

Following this conflict Wells prospered, with shipping and trade extending to the West Indies and Europe. The area was set back briefly by the War of 1812, but the glorious age of sail soon followed and this form of transportation flourished until the Civil War.

Although overland travel was difficult, as early as 1825 there were eight taverns providing comfort to the stagecoach travelers. The railroad's arrival in 1842 provided employment for the locals and accessibility from points north and south. The rails would soon become the means of transporting freight previously carried by schooners.

By the mid-1850s our barrier beaches were being discovered by businessmen from Dover and Berwick. Although "tourism" didn't flourish until this century, this was the beginning of the awareness of our cool summer climate.

When attempting to best describe Wells, one must consider its geographical content and size. Now approximately 60 square miles in size, its original boundaries included the towns of Kennebunk and Ogunquit. The number of rivers and brooks in the area was one of the enticements to early mill owners. Clusters of farms were concentrated near rivers and brooks, where the mills operated. Usually evident in these areas of concentrated population were a blacksmith shop, store, and post office. A local one-room school and a church provided the

social and cultural opportunities for each area.

The original land grants to the first settlers in Wells stretched 2.5 miles inland from the upper edge of the marsh. The farmsteads and gardens were followed by orchards, pasture land, hay fields, and inland woodlots. The inland boundaries were where Ridge and Branch Roads are today. On early deeds this was called Upper Post Road and was parallel to Lower Post Road (Route One).

The 1872 Cadastral Map divides the town into seventeen school districts. Although by 1900 several of these had merged, the settlement pattern was established. The various sections of Wells today are derived from these times. We shall look at the Coles Corner, Wells Corner, Eldridge Corner, Moody, Tatnic, Merriland Ridge, High Pine (formerly called Wells Depot), and Wells Branch sections.

Acknowledgments

To visualize the town of Wells in a composite such as this, one can only attempt to scratch the surface in terms of people, places, and things that might have been photographed. The average person did not own a camera. Traveling photographers are responsible for the photographs of families posing outside their homes. Merchants hired photographers to take photographs of their establishments and other attractions. Postcards are our major pictorial connection with our community at the turn of the century.

When compiling this project I knew that my own collections were inadequate. Therefore, I am extremely grateful to the following people and organizations for sharing theirs: to the Historical Society of Wells & Ogunquit, for the Nason and Kimball Collections; to Karen and Robert Bragdon, Betty Chase, Francis Chick, Fen Clark, Ron Collins, Tom Fenderson, Vander Forbes, Betty Goodwin, Willis Gowen, Barbara, Louise, and Willis Hanson, Bertha, David, and Philip Hilton, Doris Houston, Nadyne and Charles MacDonald, Peter Moody, Janet Schorer, Helen and Richard Segal, Claire Tracy, Randolph West, and Hilde Woodward, for loaning their pictures; to Eleanor Litchfield, Mary Luce, and Irene Wormwood, for assisting me in identifying folks; to Charlotte Moody, for her encouragement and suggestions; and to Mona Smith, for her assistance, support, and computer skills.

I ask the indulgence of all readers for any errors or omissions.

One

Historic Sites

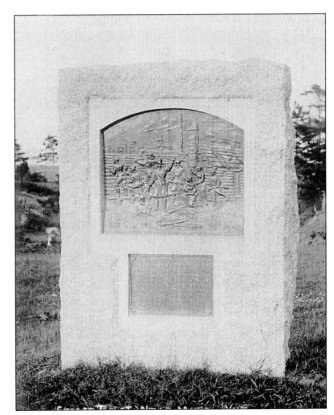

THE STORER PARK MONUMENT. The inscription reads: "To commemorate the defense of Lt. Joseph Storer's Garrison on this ground by Capt. James Converse, 29 Massachusetts Soldiers, the neighboring yeomanry of Wells and various historic women: June 9, 10, and 11, 1692, whereby 400 French and Indians were successfully resisted, and Wells remained the easternmost town in the Province not destroyed by the enemy."

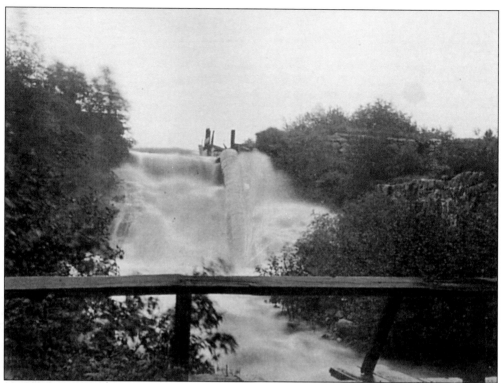

THE FALLS ON THE WEBHANNET RIVER. This was the site of the first permanent settlement in Wells, where in 1640–41 Edmund Littlefield established his saw and gristmills.

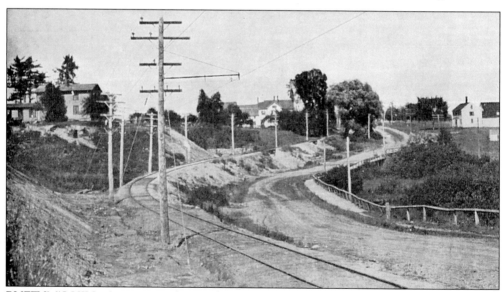

BUFFUM'S HILL. At one time this was known as Breakneck Hill. This early 1900 photograph shows the Mill House, the tracks for the Atlantic Shore Line, and the bridge over the Webhannet River. Edmund Littlefield's house was on the north side of the river in the approximate location of the Country Hill Motel (in the upper left of the picture). The Samuel Black Littlefield house (John Houston's—see p. 47) can be seen in the upper right.

THE REVEREND JOHN WHEELWRIGHT (1592–1669). Reverend Wheelwright established the Congregational Way in Wells in 1642 when he and his followers fled here for religious freedom.

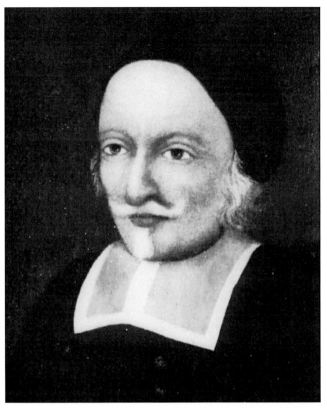

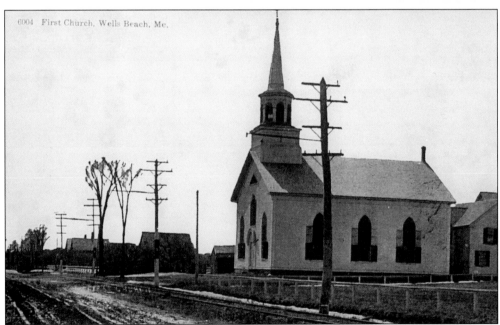

6004 First Church, Wells Beach, Me.

THE FIRST CONGREGATIONAL CHURCH. This 1862 National Register landmark is the fourth building on this site. The original church built in 1662 was burned by Indians in 1692. Now owned by the Historical Society of Wells & Ogunquit, this is the Meetinghouse Museum.

STORER PARK. This park is owned and maintained by the State of Maine. This 1932 postcard shows the landscaping at that time.

THE GARRISON HOUSE. In 1816 Captain Isaac Pope built this home from the timbers of the original Storer Garrison, made famous in the 1692 battle. The original garrison stood on a bluff adjacent to the marsh.

12

Two

School District No. 1

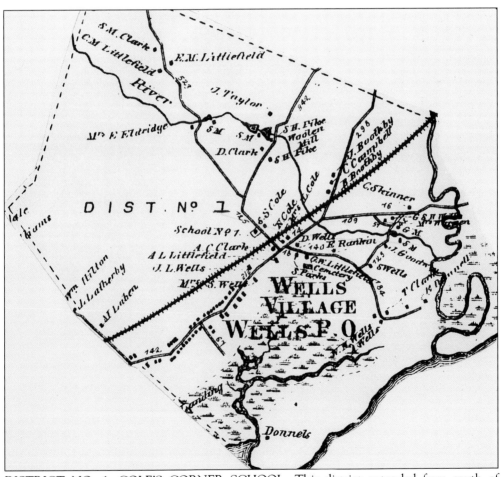

DISTRICT NO. 1, COLE'S CORNER SCHOOL. This district extended from south of Harriseeket Road to Burnt Mill Road on the west side of Post Road. Inland it encompassed Cole's Hill. The original school was located on Cole's Hill Road as noted on this map.

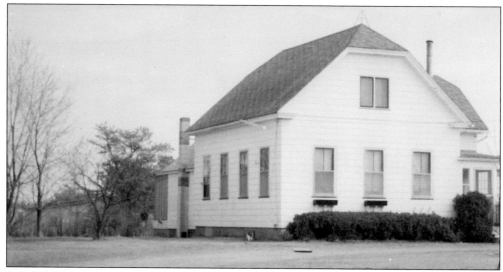

DISTRICT NO. 1, THE ELMS SCHOOL. This school was built in 1899 through the generosity of Robert W. Lord. The name and location were changed at that time. This former school is now a private residence.

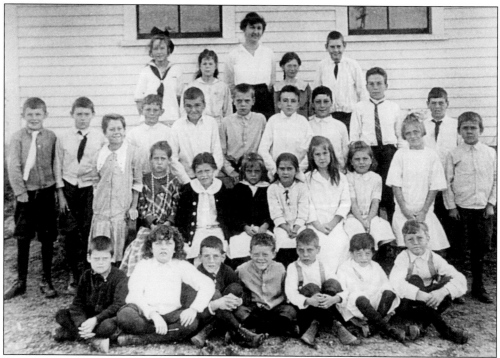

DISTRICT NO. 1 IN 1915. From left to right are: (front row) Forest Brown, Leo Houston, Lawrence Allen, Willie Collins, Herbert Strickland, Willie Brooks, and Kenneth Hill; (second row) Margaret Campbell, Agnes Campbell, Nellie Hutchins, Sadie Strickland, Louise Campbell, Hazel Tobey, Helen Berry, Esther Allen, and Robert Campbell; (third row) Cornelius Collins, William Brown, Carlton Hill, Francis Hill, Clarence Strickland, Ellwyn Houston, ? Brooks, Floyd Strickland, and Alfred Allen; (back row) Gladys Hill, Mary Collins, Elsie Littlefield (teacher), Irva Smith, and Clarence Berry.

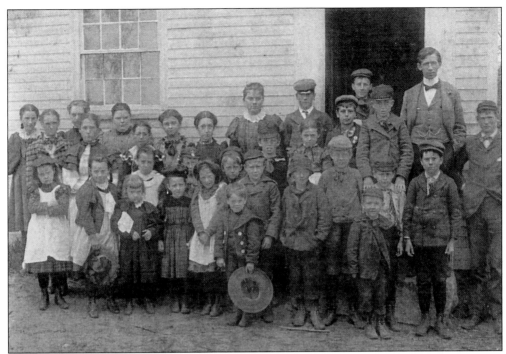

DISTRICT NO. 1, COLE'S CORNER SCHOOL. At this time the old school was in need of repairs. School was held in Frank Clark's Carriage House. Thornton Bodge was the teacher.

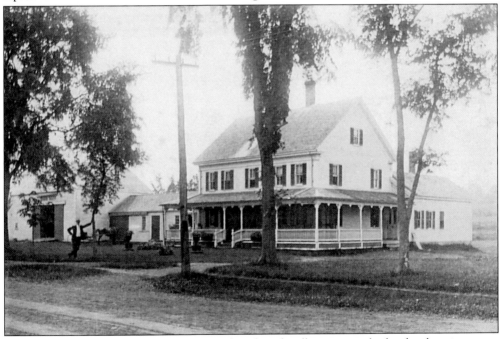

THE FRANK CLARK HOMESTEAD. Before the schoolhouses were built school sessions were held at private homes. At the turn of the century classes once again had to be held in private residences. This home also was the post office for the area at one time. Now it houses the Lighthouse Depot.

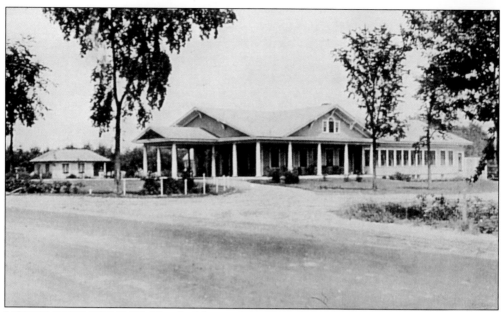

LIBBY'S RESTAURANT. This building was built in the early 1920s. It was reportedly the largest bungalow in New England at that time. It has served in many capacities over the years, and now belongs to the Johnson family.

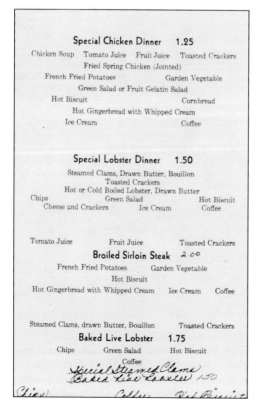

Special Chicken Dinner 1.25
Chicken Soup Tomato Juice Fruit Juice Toasted Crackers
Fried Spring Chicken (Jointed)
French Fried Potatoes Garden Vegetable
Green Salad or Fruit Gelatin Salad
Hot Biscuit Cornbread
Hot Gingerbread with Whipped Cream
Ice Cream Coffee

Special Lobster Dinner 1.50
Steamed Clams, Drawn Butter, Bouillon
Toasted Crackers
Hot or Cold Boiled Lobster, Drawn Butter
Chips Green Salad Hot Biscuit
Cheese and Crackers Ice Cream Coffee

Tomato Juice Fruit Juice Toasted Crackers
Broiled Sirloin Steak 2.00
French Fried Potatoes Garden Vegetable
Hot Biscuit
Hot Gingerbread with Whipped Cream Ice Cream Coffee

Steamed Clams, drawn Butter, Bouillon Toasted Crackers
Baked Live Lobster 1.75
Chips Green Salad Hot Biscuit
Coffee

A LIBBY'S RESTAURANT MENU. One of the specialties of the restaurant was its fried chicken dinners. Sandwiches averaged 30¢ each, with the exception of lobster, which was 60¢; soups and chowders were 25¢; ice cream was 15¢; and fruit shortcakes were 35¢.

16

YE COSIE CORNER. This restaurant first opened as a booth in the late 1920s. Owned and operated by Mary Louise Chapell, business increased each year. Her inn and restaurant were so popular that she was fondly called "Mother Chapell." Chicken pies were her specialty.

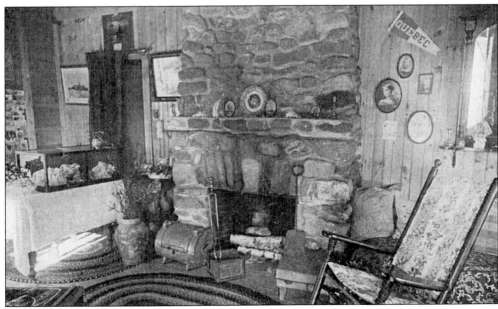

YE COSIE CORNER. One corner of the restaurant was this cozy spot. The restaurant was operated by a variety of folks until it was torn down to straighten the road by the iron bridge. It was located at the intersection of Post and Port Roads (Route One and Route Nine).

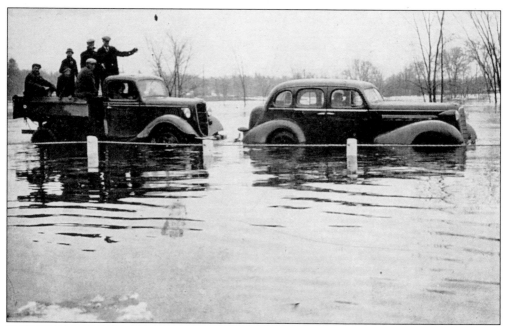

THE GREAT FLOOD OF 1936. These vehicles became stranded on Post Road in the general location of the Port Road intersection. This is where the Merriland River flows out to sea—and occasionally over its banks, as can be seen here.

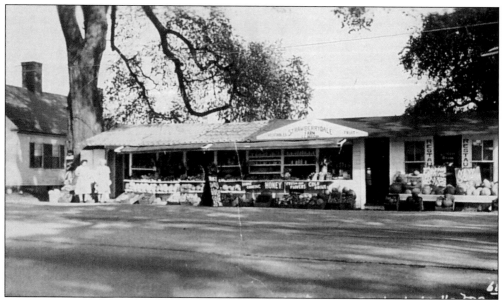

THE STRAWBERRY DALE FARM. This farm stand and restaurant was owned by Charles C. Houston, and provided fresh produce as well as meals to the motoring public. Mrs. Houston and Jennie Boston are standing at the left of the picture. Big Daddy's is at this location today.

18

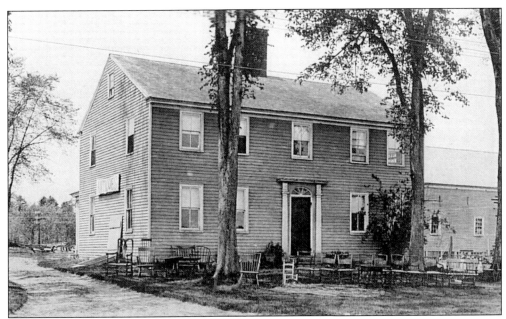

THE COLE FARM. Once the Cole family homestead and farm, this postcard shows F.C. Higgins displaying his antiques early in this century. It is now part of the Cole's Corner Complex.

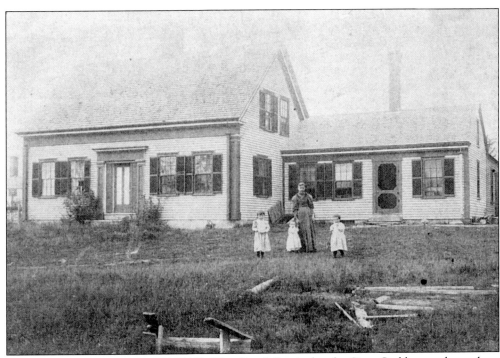

THE COLE FAMILY HOMESTEAD. This Greek Revival-style, Cape Cod home, shown here at the turn of the century, was once the residence of Nicholas and Dorcas Cole. Their daughter, Marietta Cole Smith, stands with her children: Emma, Charles, and Ethel Smith.

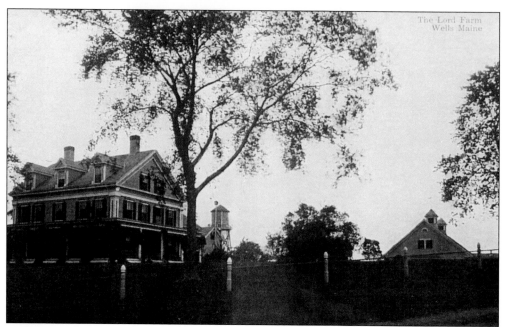

THE LORD FARM. George C. Lord purchased this farm from the estate of Theodore Clark in 1881. The roof was raised to add a third floor and expansive porches and embellishments were added. He called this the Elms Farm.

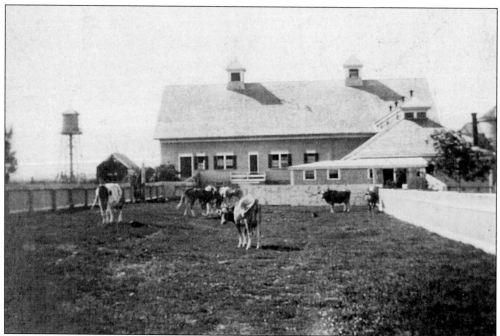

THE ELMS FARM. The barn burned in 1905 and George C. Lord's eldest son, Robert, replaced it with this "Jamesway" structure. Robert introduced Guernsey cows but continued his father's "gentleman farmer" tradition of only being in residence primarily in the summer. Local herdsmen and farmers operated the farm for him. Robert's brother Charles inherited the farm in 1908 and changed its name to Laudholm Farm.

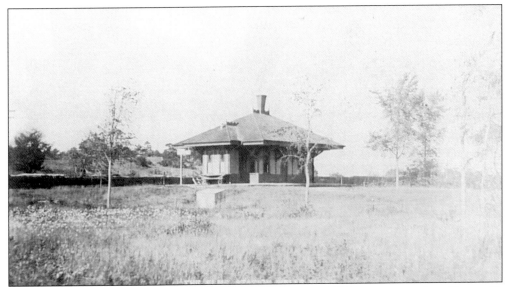

THE ELMS STATION. This railroad station was built in 1888 to accommodate George C. Lord, president of the Boston & Maine Railroad. Today it is a portion of Harding's Map & Print Gallery.

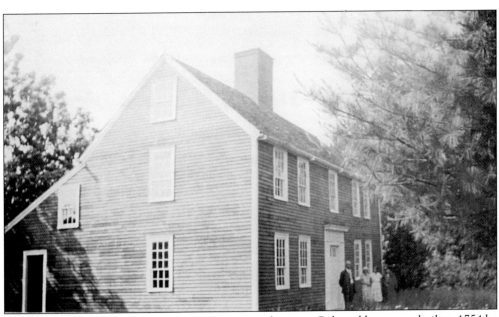

JEFFERD'S TAVERN. This salt box-style, center chimney, Colonial home was built c. 1754 by Captain Samuel Jefferds. Located on Cole's Hill on a road that crossed to the Harriseeket section, it served as a haven for travelers during the Revolution. When the turnpike to Kennebunk was built in the early 1800s, this road was no longer used. Restored by historian William Barry, the house was dismantled in the late 1930s and relocated at York. This 1932 photograph shows it in its original location in Wells.

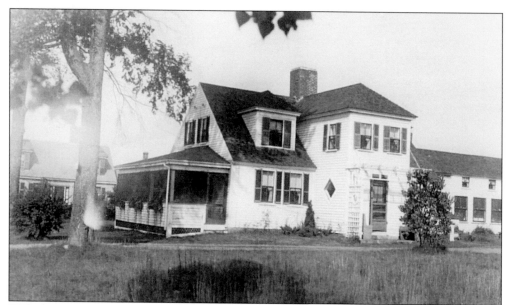

THE HEMMENWAY HOUSE. This modified Cape Cod-style home was probably built by one of Reverend Moses Hemmenway's sons. Reverend Moses was the pastor at the First Congregational Church for fifty-two years (1759–1811). A Harvard College graduate, he was recognized as one of the eminent theologians of his day. This home is privately owned and is located on the east side of Post Road south of Drake's Island Road.

NOBLE'S ANTIQUES. In the 1920s the barn to the Hemmenway property housed Noble's Antiques. The rooster weather vane, reportedly a James Lombard wood sculpture, is now in a New York museum.

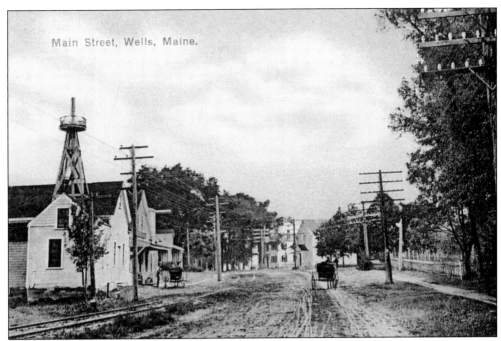

MAIN STREET. This early 1900 postcard of Post Road looking north shows Rankins Store (on the left) and the Benevolence Society's building (on the right, in front of the horse and buggy). This section of town was often called Rankinville due to the number of families of that name that resided here.

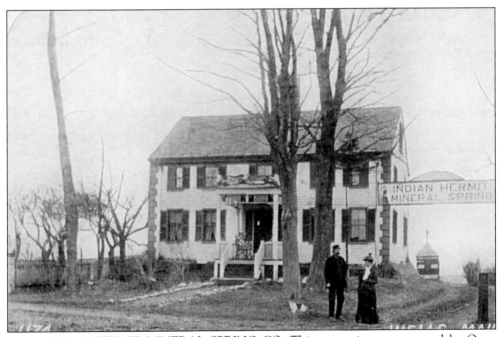

THE INDIAN HERMIT MINERAL SPRING CO. This enterprise was operated by Oscar Hubbard during the early part of this century. The Moxie bottling works was housed in what is now Howe's Floor Store. Many Facettes now occupies the former Hubbard home.

SEAVIEW MOTOR COURT. This was one of several converted farmsteads on Post Road catering to automobile travelers in the 1920s and '30s. Originally Captain Samuel Lindsey's home, this building was destroyed a few years ago. The Sea-Vu Campground is at this site today.

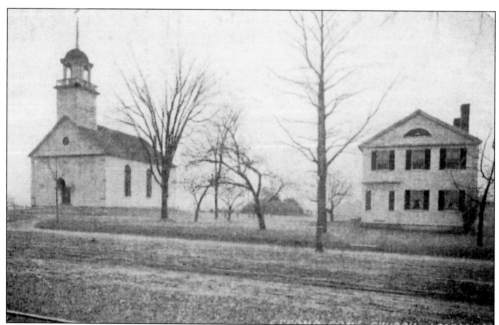

THE SECOND CONGREGATIONAL CHURCH AND PARSONAGE. The Second Congregational Church was organized in 1831, with the church building being built soon after. The First and Second Churches merged in 1964 and now utilize this church as their home. When a new parsonage was built this one was moved and the church's parking lot now utilizes the space.

Three

School District No. 2

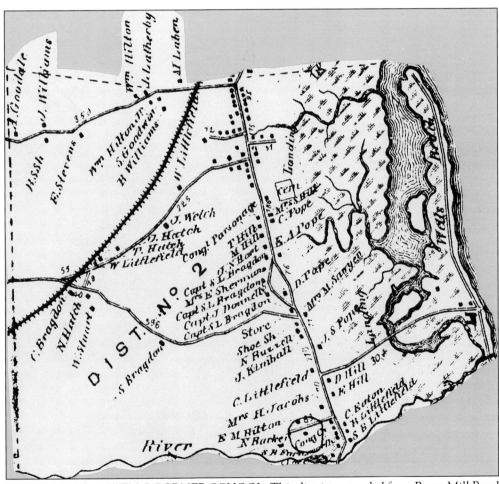

DISTRICT NO. 2, WELLS CORNER SCHOOL. This district extended from Burnt Mill Road south to the Webhannet River. The center of the town then was at the intersection of Post and Sanford Roads (Route One and Route 109) and known as Wells Corner.

MATHEW LINDSEY (1774–1843). Mathew came to Wells from York in the mid-1700s and built Ye Lindsey Tavern in 1799. His descendants owned the property until 1928.

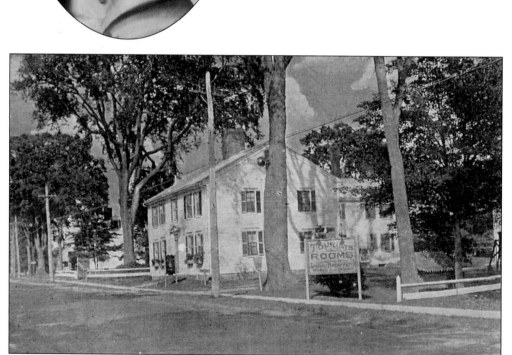

YE LINDSEY TAVERN. This tavern served as the stage stop and for many years was the local post office. Following the War of 1812 returning soldiers were guests here. During General Lafayette's tour of the United States in 1825, he stopped here and spoke to the people of the town from the front steps.

Ye Lindsey Tavern

FREDERICK GLANVILLE GLADYS GLANVILLE

Shore Dinner
Clam Chowder or Juice

Fried or Steamed Clams

Lobster Salad Hot Rolls

Choice of Desert

Tea or Coffee 2.25

Lobster Dinner
Lobster Stew or or Juice

Fried or Steamed Clams

French Fries - Salad - Onion Rings

Baked - Broiled or Boiled Lobster

Hot Rolls

Choice of Dessert

Tea or Coffee 3.25

Steak Dinner
Chowder or Juice

Steak Onion Rings

French Fried Potatos

Choice of Dessert

Tea or Coffee 3.75

Chicken Dinner
Chowder - Juice - Fruit Cup

Half Broiled Chicken French Fries

Vegetable Salad Hot Rolls

Choice of Dessert

Tea or Coffee 2.25

A YE LINDSEY TAVERN MENU. The Glanville family continued the restaurant traditions of the tavern until 1956. The tavern has had several titles in the past few years but resumed its original title in 1995.

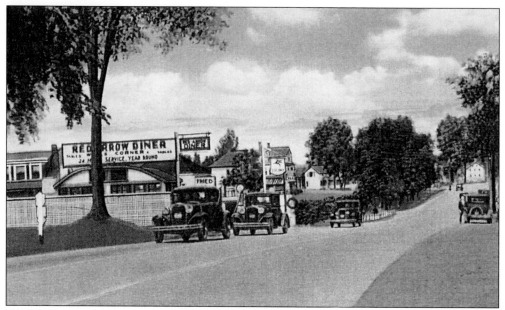

THE RED ARROW DINER. Looking north on Post Road at Wells Corner in the 1930s, the Red Arrow Diner can be seen on the left. This was a popular eating spot at that time.

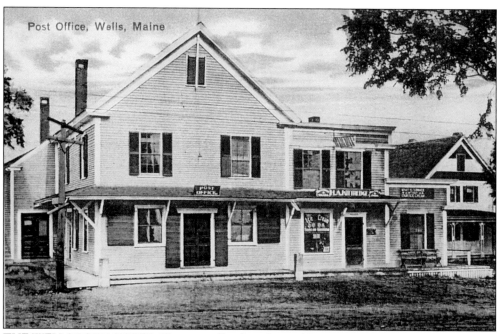

THE WELLS POST OFFICE. The post office has changed locations many times over the years. At this time it was located on the north corner of the intersection of Sanford and Post Roads.

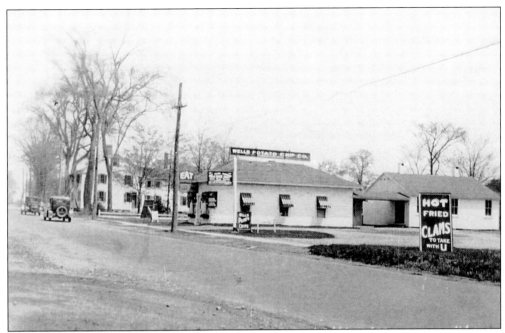

THE WELLS POTATO CHIP CO. This lunch and tea shop was operated by Mabel and Marion Davis and Catherine Hubbard in the mid-1920s. The building behind the lunchroom was where the potato chips were made. Charles Goodwin cooked the chips. George Chaney on Littlefield Road (9B) grew the Russet potatoes. Ocean National Bank is located on the site today.

THE MONUMENT TO WORLD WAR I HEROES. This marker and flag pole were originally located on an island at the intersection of Harbor and Post Roads. Today the monument is located at the Ocean View Cemetery.

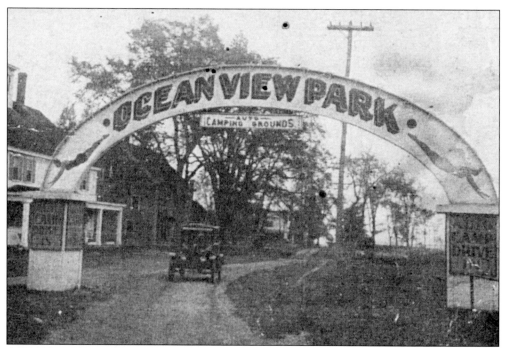

OCEAN VIEW PARK. This grand sign over Harbor Road advertised John N. Davis' campgrounds, cottages, and swimming facilities in 1926.

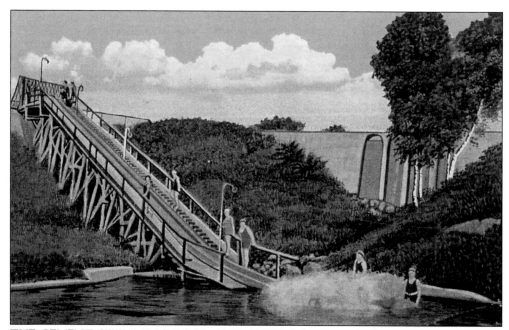

THE CEMENT SWIMMING POOL AND SLIDE. John Davis built a 100-by-50-foot pool utilizing the natural elevation adjacent to the marsh for the 105-foot chute (water slide). Springboards for divers and a variety of water depths made it fun for young and old alike.

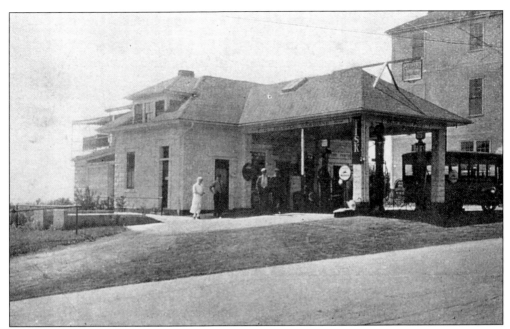

A WELLS FILLING STATION. J.W. Dinsmoor was the proprietor of this gas station when this photograph was taken in the late 1920s. The fire station is at this location today.

MOULTON'S STORE AND FIRST NATIONAL. At the intersection of Sanford and Post Roads, Moulton's Store and the First National Store occupied the west side of Post Road. The post office moved to the town hall across the street and the First National Store occupied this site at Wells Corner.

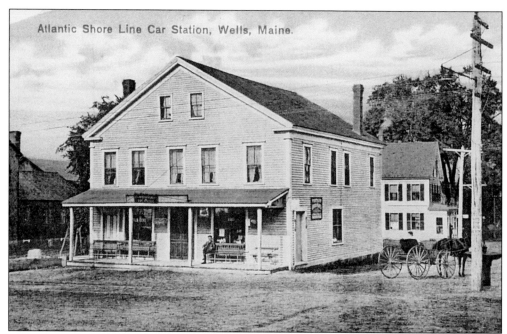

Atlantic Shore Line Car Station, Wells, Maine.

THE ATLANTIC SHORE LINE CAR STATION. Moulton's Store began business in 1885, and served as the station for the electric cars and as a bus stop in later years. This Wells Corner landmark is now the Pizza Shop.

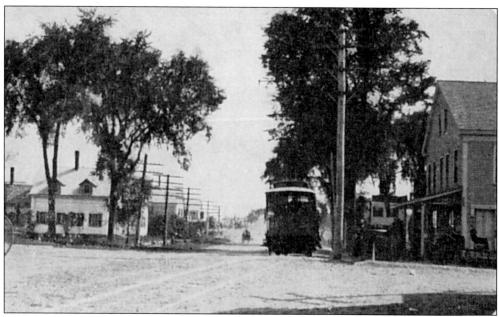

MAIN STREET—POST ROAD—STATE ROAD—ROUTE ONE. All of these titles refer to the same road in Wells. Looking south from the corner, this postcard notes three modes of transportation in early 1900s: the wagon wheel (left), an automobile (in the distance), and the electric car (in front of Moulton's Store).

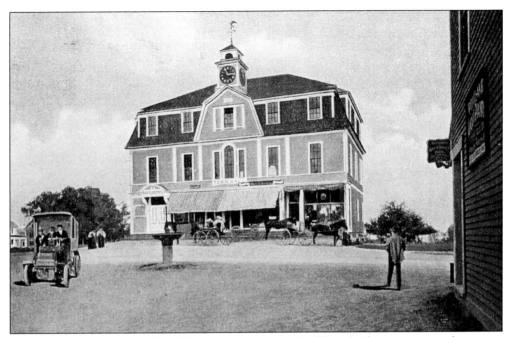

THE WELLS TOWN HALL. This was the second building built to accommodate town functions. The original building was located opposite the present entrance to the turnpike. In 1904 it was destroyed in a fire caused by the sparks of a train of the Boston & Maine Railroad, which owned tracks adjacent to the building. This second building was also consumed by fire in 1911.

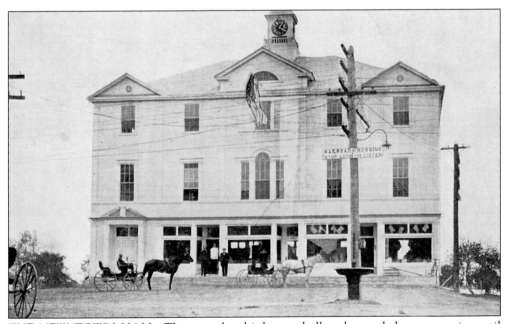

THE NEW TOWN HALL. This was the third town hall and served the community until 1967, when it was demolished. The current police station-town hall annex served as the fourth municipal building until 1988, when the fifth and current facility was built.

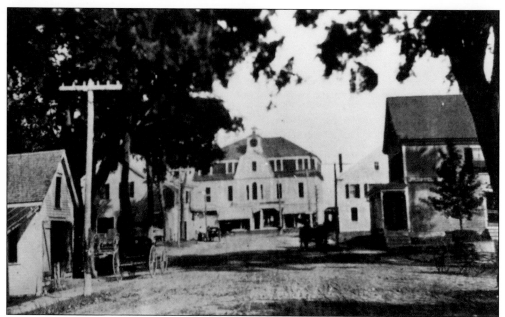

DEPOT STREET, WELLS. This early postcard view was taken looking east toward the town hall. Depot Street obviously is the road leading to the train station. Today we know it as Sanford Road. On earlier deeds it was also known as Merriland Road, being one of several roads to the Merriland Ridge section of town.

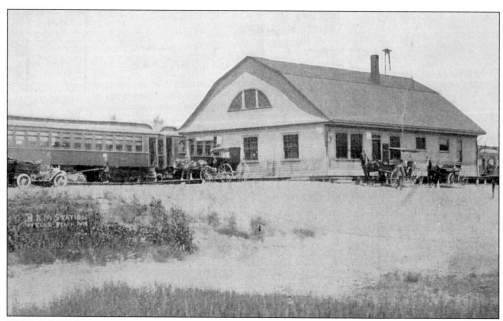

THE BOSTON & MAINE STATION, WELLS BEACH. The Boston & Maine Railroad station was built in 1872. The first station built at that time burned at about the same time as the first town hall. Thus, this is the second station at this site. It was called Wells Beach to distinguish it from the earlier PP&B line at Highpine (called Wells Depot).

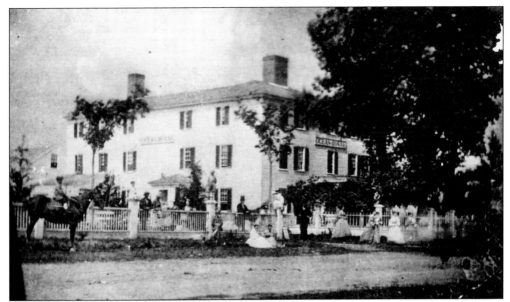

THE OCEAN HOUSE. Located south of Wells Corner on the west side of Post Road and north of today's junior high school, this hotel was built c. 1860. John Storer was noted as the owner and possibly the builder at that time. Flames consumed this landmark on June 23, 1889, when Bion Tripp was the proprietor.

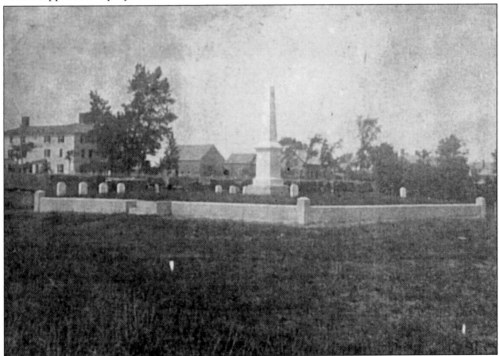

THE CIVIL WAR MONUMENT. This monument at the Ocean View Cemetery was erected by John Storer, Esq., and the people of Wells to commemorate the men of Wells who gave their lives during this conflict. Note that the Ocean House can be seen across the street in the left of this early photograph.

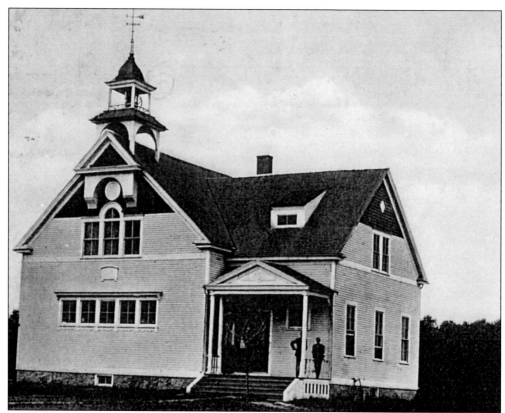

WELLS HIGH SCHOOL. The first high school in Wells was occupied in December 1903. It was located at the same location of the Post Road (Route One) campus of the school today.

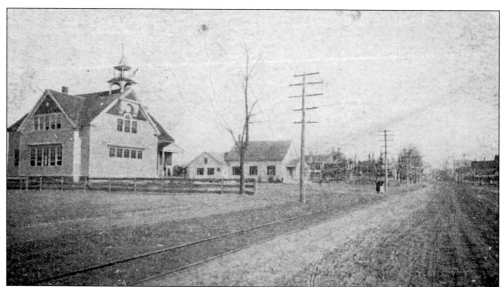

DISTRICT NO. 2. This postcard shows the elementary building adjacent to the high school. The Atlantic Shore Line tracks and poles indicate the photograph was taken after 1907.

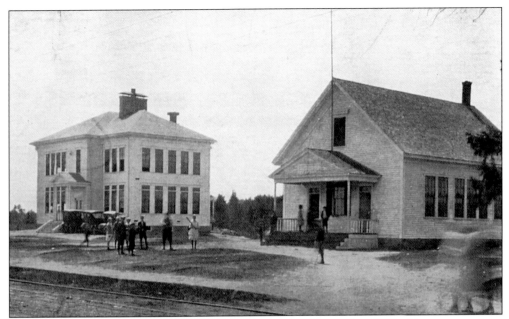

THE NEW HIGH SCHOOL. When the first high school burned *c.* 1909, this two-story, hip-roofed building replaced it. The same elementary school is at the right.

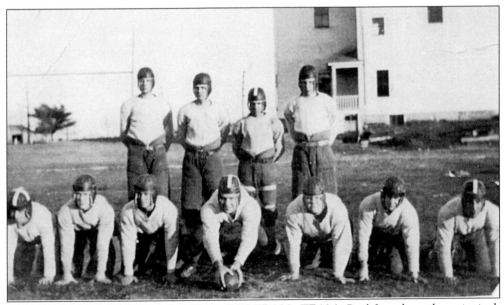

THE FIRST WELLS HIGH SCHOOL FOOTBALL TEAM. Paul Larrabee, the principal, wrote in his 1926 report that athletics had become an integral part of school training. He was pleased that during a forty-eight-hour time frame in the fall of 1925, $125 was raised to support the new football team. The only member identified is Clifford Moody (on the far right of those kneeling).

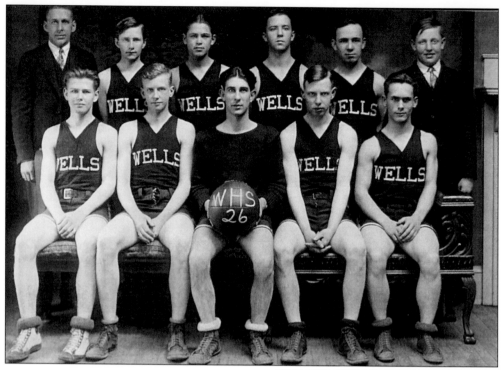

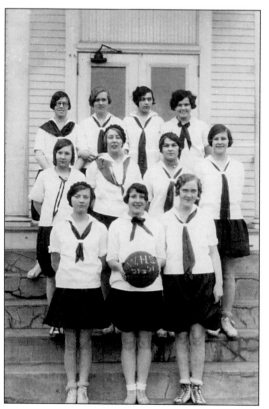

THE 1926 WELLS HIGH SCHOOL BASKETBALL TEAM. Although basketball is alluded to in high school newsletters prior to World War I, this is the earliest team photograph to surface. From left to right are: (front row) unknown, Donald Freeman, Clifford Moody, Prescott Spaulding, and Dwight Kimball; (back row) Paul Larrabee (coach and principal), Frank Sawyer, Robert Hatch, unknown, Dexter Bradbury, and Chester Littlefield (manager).

THE 1928–29 WELLS HIGH SCHOOL GIRLS BASKETBALL TEAM. The girls had a team by the mid-1920s, but again this is the earliest photograph found. From left to right are: (front row) Helen Perkins, Marion Campbell, and June Littlefield; (middle row) Dorothy Boston, Elizabeth Spaulding, Eleanor Campbell, and Blanche Hutchins; (back row) Irene Bridges, Esther Littlefield, Ellida Hawkes, and Marjorie Fenderson.

THE PARSONAGE OF THE CONGREGATIONAL CHURCH. In 1727 the church voted to build a parsonage for Reverend Samuel Jefferds. It was to be 38 feet long, have an 18-by-16-foot ell, and a large barn. Mrs. Jefferds insisted on a surrounding stockade as Indian skirmishes still occurred. Reverend Jefferds was escorted to Kennebunk to preach with an armed guard. The building, shown here in 1940, was used until 1907 as the minister's home. Today the library stands in the approximate location.

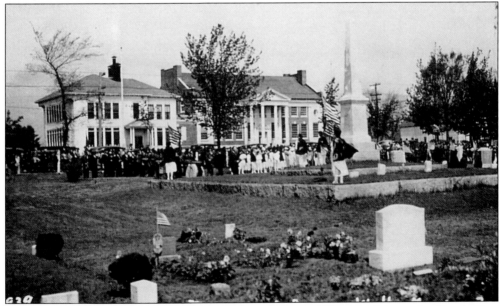

MEMORIAL DAY. This 1939 photograph shows Memorial Day activities at the Ocean View Cemetery. In the background, the third high school building (built in 1937) sits to the right of the second, which was being used for the elementary students. Before this year was over the elementary building would be destroyed by fire.

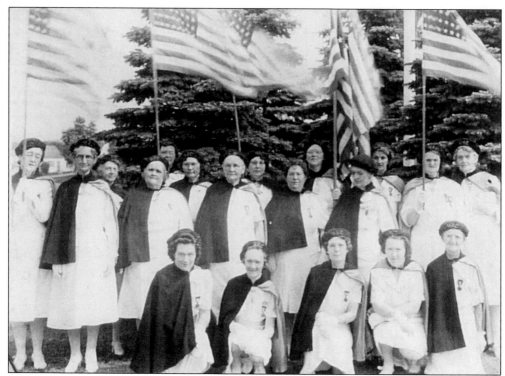

THE WOMEN'S RELIEF CORPS. This was an active organization in Wells until this decade. One of their activities was decorating the graves of servicemen. From left to right are: (kneeling) Esther Hutchins, Theresa Hubbard, Bessie Kimball, Dorothy Hubbard, and Mabel Perfect; (standing) Beatrice Nutter McNudge, Hattie Boston, Ruby Hanson, Sadie Matthew, Gertrude Card, Gertrude Hatch, Ethel York, Elsie Matthews, Marion Bridges, Ethel Kelley, Myrtle Moulton, Clara Beyea, Alice Davis, and Clarissa Hilton.

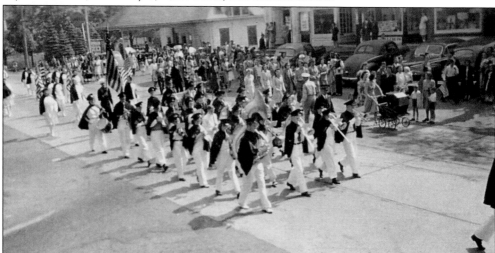

MEMORIAL DAY: THE WELLS SCHOOL BAND AND THE WOMEN'S RELIEF CORPS. This photograph, taken in 1944, shows the annual parade through Wells Corner en route to services at the Ocean View Cemetery. Although the services today do not extend all day as they did then, this tradition of remembering still continues.

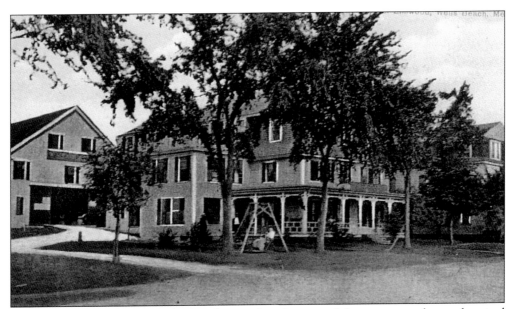

THE ELMWOOD HOTEL. This hotel opened at the turn of the century and was advertised as a "year round" accommodation. It burned in sub-zero temperatures in February 1943. School teachers, boarding there at the time, lost all their belongings. The Elmwood Annex at the south corner of Stuart Lane remains today.

THE ELMWOOD FARM. This farm was located just south of the hotel on Bayley Road and undoubtedly provided the produce that was served to guests at the hotel. In this 1914 postcard C.E. True is noted as the proprietor of both.

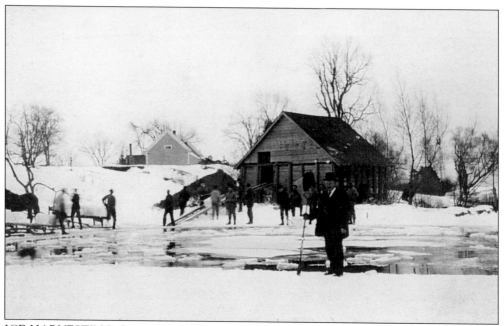

ICE HARVESTING. January was the usual month to harvest ice from the ponds. Mill Pond provided the ice which C.E. True used at the Elmwood Hotel. The ice house adjacent to the pond shows the slide on which the chunks were mounted. Packed in saw dust, the ice would last through the summer.

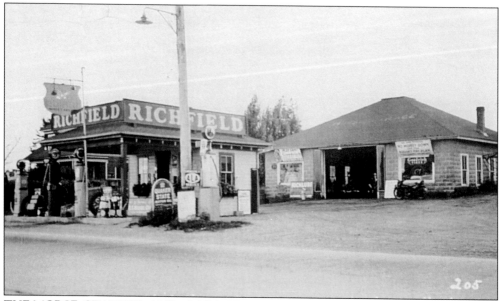

THE MORSE STATION AND GARAGE. As automobiles became more prevalent, gas stations and garages appeared. Earl Morse ran this facility. The station is no longer there but the garage is utilized by Morse Lumber operations now.

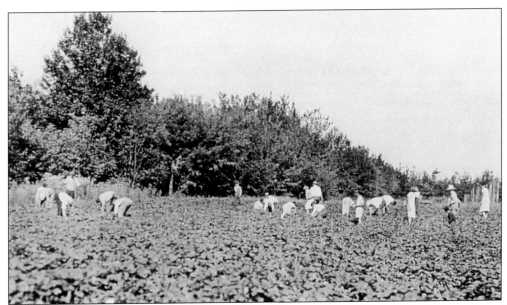

STRAWBERRY PICKING AT ATLANTIC VIEW FARM. This 1934 photograph of strawberry pickers in a patch recalls the early farms along Post Road. The field is the site of Poli's Restaurant today.

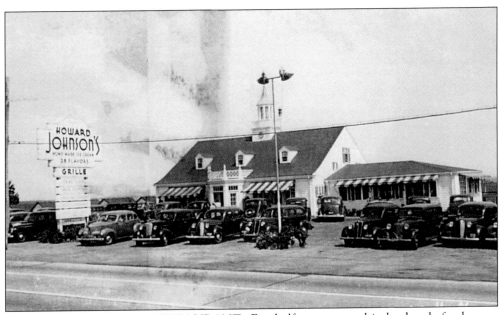

HOWARD JOHNSON'S RESTAURANT. For half a century this landmark for hungry Americans served meals and its twenty-eight flavors of ice cream to travelers along Post Road. An Irving gas station is now situated at this location.

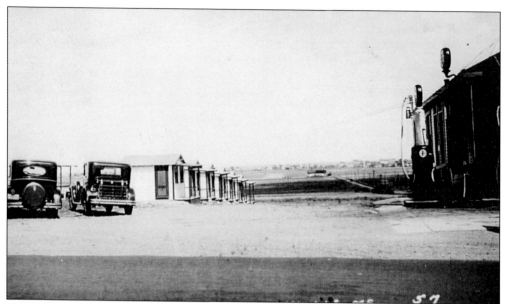

CABINS AND A GAS STATION. Located on the north corner of the intersection of the Mile and Post Roads, this business was operated for years by the Dyer family. Cabins were the accommodations in vogue prior to World War II.

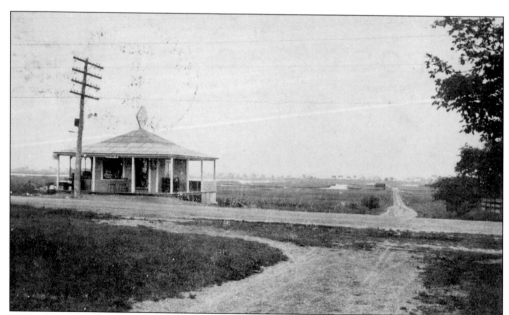

THE MILE ROAD FROM THE POST ROAD INTERSECTION. This postcard shows the store and Atlantic Shore Line station for this area. Originally the Mile Road was a private lane owned by James Buffum for the purpose of transporting his lumber to ships at the wharf on the Webhannet River. The wharf and shed can be seen on the left of the picture, halfway to the shore.

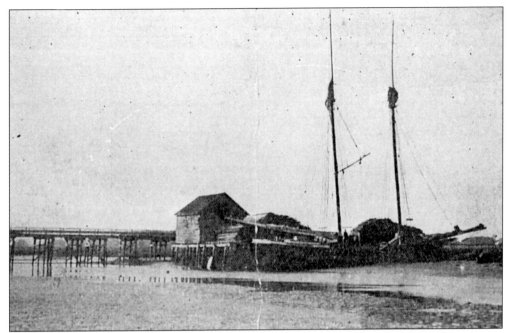

LUMBER PILED ON WHARVES. The schooner *Alice S. Wentworth* is at dock beside wharves piled high with lumber to be shipped south. The Mile Road Bridge shows its spiky supports as it spans the Webhannet River at low tide.

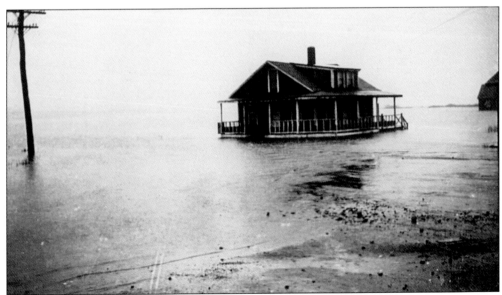

FLOOD TIDE. The Mile Road has been completely obliterated in this photograph of an extremely high tide.

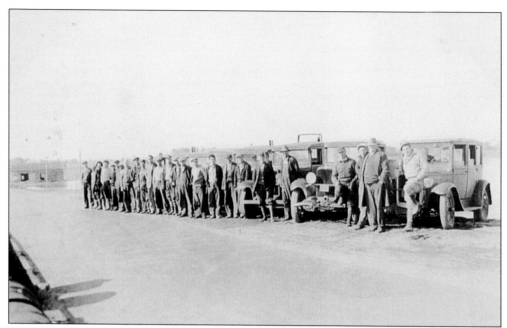

REPAIRS ON THE MILE ROAD. Archie Wormwood and other selectmen and road commissioners line up for a picture-taking session following the widening and grading of the Mile Road.

THE HILL FAMILY HOMESTEAD This home was located on the south corner of the intersection of the Mile and Post Roads, but the house and barn were eventually turned and moved east on the Mile Road. A USA Inn is now located on the original location of the Hill farm.

KINGS HOMATEC CABINS. This home and business were located where Kentucky Fried Chicken is today. The business was begun in the 1930s. The ell at the left of the main house accommodated the local barber shop for many years.

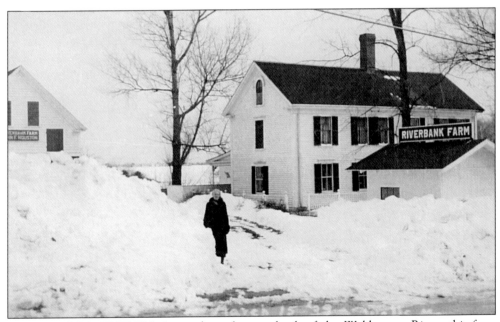

THE RIVERBANK FARM. Located on the east bank of the Webhannet River, this farm was operated by John Houston. A farm stand sold produce to the traveling public. This 1939 photograph shows Mrs. Jessie Houston and lots of snow.

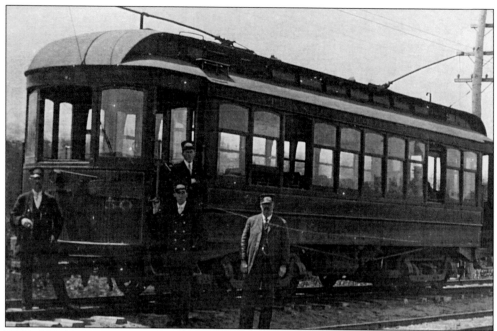

THE ATLANTIC SHORE LINE RAILWAY. These electric cars operated 1907–1923 in Wells. Local folks served as motormen and conductors. In this photograph the western division men are being relieved by men of the eastern division. Stops in Wells were located at the intersections at Moody, Eldridge Road, the Mile Road, Wells Corner, and the Elms.

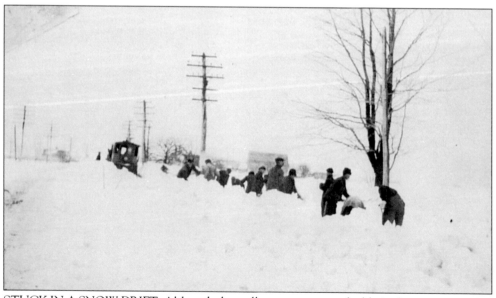

STUCK IN A SNOW DRIFT. Although the trolleys were very profitable in the summer, winter travel was minimal. Drifts across Post Road just south of the Mile Road were very common, even though snow fences were placed in adjoining fields. It's at this location that these men are shoveling to clear the tracks.

Four
School District No. 3

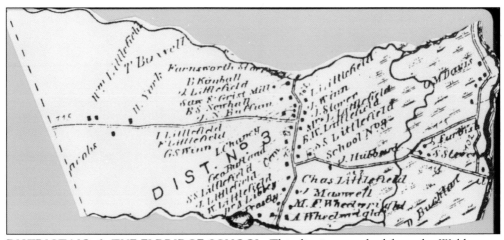

DISTRICT NO. 3, THE ELDRIDGE SCHOOL. This district stretched from the Webhannet River to Stevens Brook. The school was located on Eldridge Road. Before 1900 the town reports designate this as the Webhannet School.

DISTRICT NO. 3, THE ELDRIDGE SCHOOL. This was a one-room schoolhouse in 1907, when students gathered for this photograph. An additional room was added in 1916. This building is now utilized by the Lions Club.

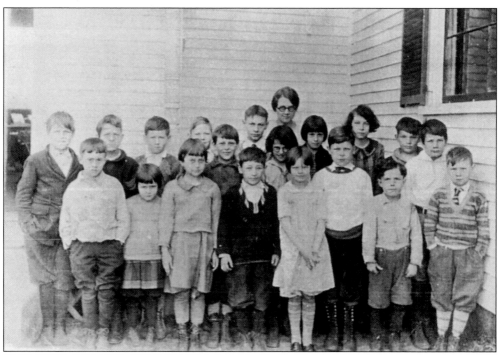

ELDRIDGE SCHOOL STUDENTS IN 1929–30. From left to right are: (front row) Carl Brown, Lillian Brown, Mary Cheney, Wilbur Downing, Marjorie Peterson, Arthur Kimball, Hurley Godfry, and Harold Daggett; (back row) Arthur Perkins, Wendell Godfry, Billy Murray, Glen Daggett, Merrill Hobson, Robert Littlefield, Doris Brown, Eleanor Brown, Ruth Pooler, Thornton Godfry, and Donald Batchelder. Edna Merrill is the teacher.

IVORY LITTLEFIELD (1829–1895). Ivory lived at Buffum's Hill. He was a teacher and taught at District No. 3. He was also a local historian who wrote a column entitled "Webhannet." His articles and his notes on the Littlefield family genealogy have provided a wealth of local information.

ANNIE BATES (1873–1942). Annie also lived in the Buffum's Hill area, where she wrote news articles about early Wells history. Her writings, diaries, and scrapbooks have proved to be an invaluable resource to researchers.

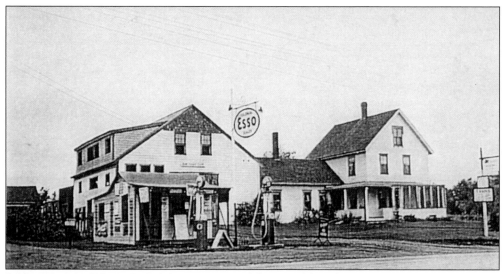

BARNES CAMPS AND ROOMS. Operated by Harold and Beulah Barnes, this business, located on the west side of Post Road, obviously sold Esso gas as well. The camps were at the left of the barn separated by a driveway. An Antiques Mart is at that location today. The house has seen use not only as a home but also as a restaurant and is now Wonderland Antiques.

THE SCOTIA HOUSE. Located at the north corner intersection of Littlefield Road (9B) and Post Road, this house was demolished in the 1960s as Route One was widened. The front section was originally the Littlefield Tavern at the corner of Eldridge Road. The house was moved to this location when the Eldridge Tavern was built.

LEROY NASON (1875–1955). Leroy Nason was a photographer who lived at Wells Beach in the summer. Frequently he rented the Scotia House or other available houses during the winter. His photographs from the mid-1890s to the 1950s provide a wonderful pictorial history of Wells.

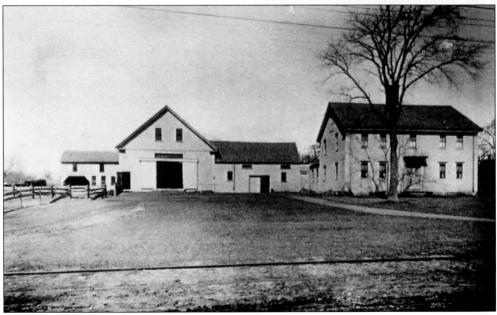

THE AUGUSTUS LITTLEFIELD FARMSTEAD. A pasture and an orchard were located to the left of the barn until the middle of this century. The barn was then moved and turned to become apart of the Arundel Cabinet Works complex. Wells Highland now intersects the property occupying the pasture and woodlots. The main house has been a restaurant and is now the Wells Paint & Paper Shop.

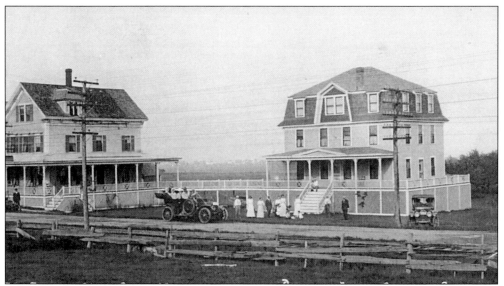

THE OSCEOLA. This hotel was first advertised in 1910 but both buildings were originally homes of the Littlefield family. Joined by an open deck and walkway, these were attractive stopping places for the traveling public. The hotel provided regularly-scheduled transportation to the beach. Wealthy summer boarders would come for several weeks, if not the whole season. The building on the left is now an apartment complex. The building on the right is the Just For Kids outlet.

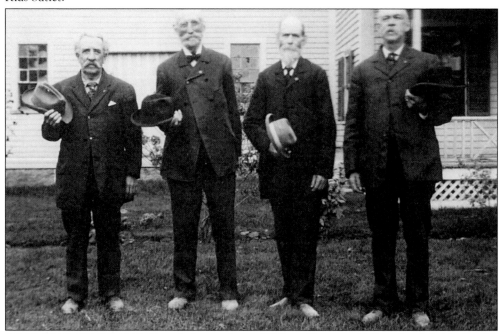

CIVIL WAR VETERANS. From left to right are William Sherwin, Gideon Littlefield, Charles Smith, and Jonas C. Littlefield. They served in F Company, 8th Maine Infantry, and experienced many battles together (two were even imprisoned at one point). This photograph was taken in 1909 when they had a reunion. They related their experiences to photographer, Lester Kimball, who recorded them for posterity.

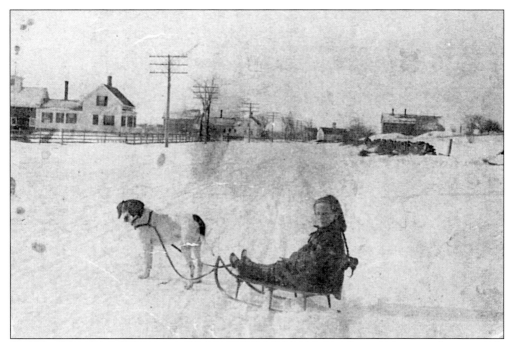

PEDRO, THE FASTEST DOG TO HARNESS IN MAINE. This 1906 postcard states: "He can haul 1800 feet green lumber any day, Speed 2:10, Kind and gentle." It has been noted in early records that dogs were used by settlers for work and conveyance. Enjoying this sled ride on Post Road is Ruth Moody. The Batchelder Farm is in the left of the photograph.

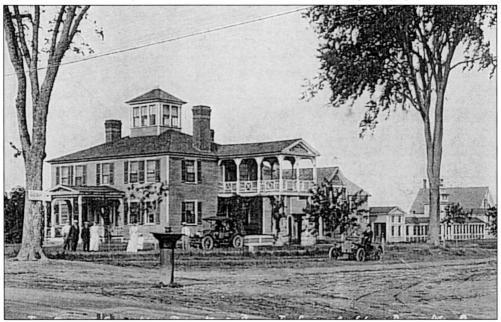

THE ELDRIDGE TAVERN. This building, located at the north corner of Eldridge Road, was built in 1824 by Captain Theodore Eldridge. In bygone days, sleighing parties used to warm themselves here with a hot toddy and dance the evening away. Today one can cool off with an ice cream at the Scoop Deck, located in the ell section of the building.

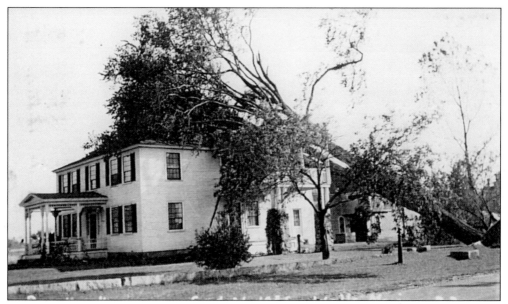

THE ELDRIDGE FARM. One of the most severe hurricanes to hit New England occurred in September 1938. This was just one of many buildings damaged by falling trees.

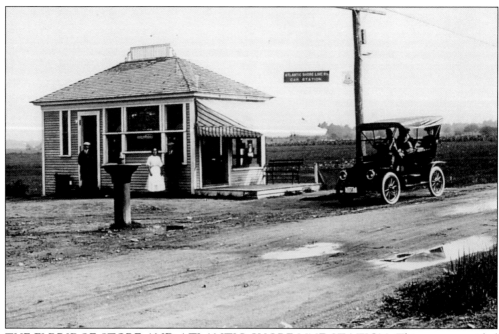

THE ELDRIDGE STORE AND ATLANTIC SHORE LINE STATION. This store provided products for this district and also served as the stop for the electric trolley. Note the public drinking fountain "for man and beast" placed by the water company in 1907.

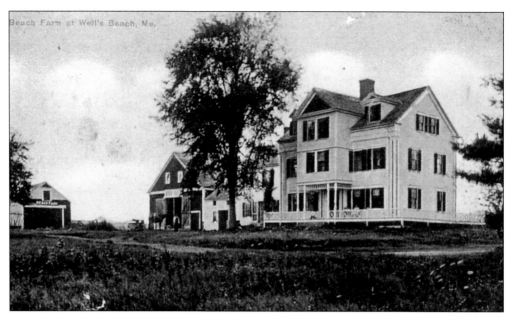

THE BEACH FARM. Located on Eldridge Road, the farm was advertised on this postcard as: "70 Acres of smooth level land within a half mile of the beaches. The house has 16 furnished rooms well arranged for a boarding house." J.M. Davis was the agent promoting the property in the 1920s. Most recently this has been a bed and breakfast.

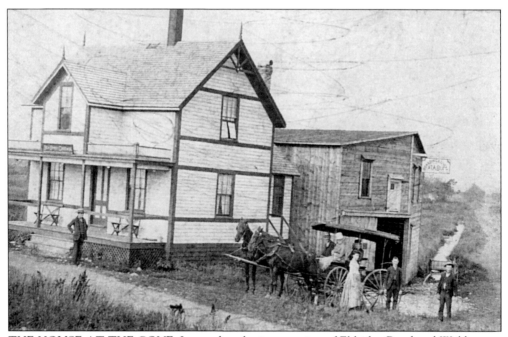

THE HOUSE AT THE COVE. Located at the intersection of Eldridge Road and Webhannet Drive, this home was the residence of Mabel and Lester Kimball for many years. This location was ideal for Lester's vocation as a photographer.

LESTER KIMBALL (1877–1962). Lester was a photographer who has left us with many likenesses of early Wells. A historian and genealogist as well, his manuscripts provide valuable insight into the first half of this century.

THE OLD MILL AND HOUSE. This sawmill at Stevens Brook was the last of several mills located here over the years. The Cape Cod-style farmhouse faces south and is one of fifteen in Wells on the National Register of Historic Places. The Hammond and Treadwell families resided here in the 1600s. It is now part of the Jorgensen's Antiques complex.

Five

School District No. 4

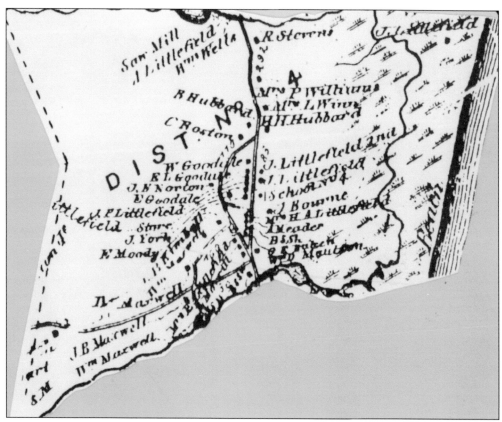

DISTRICT NO. 4, THE VARRELL'S CORNER/MOODY SCHOOL. This district encompassed the area from Stevens' Brook to the Ogunquit River. The school acquired its name from the owner of the community store that sat on the opposite side of the street. Hence, when William Varrell had the store it was Varrell's Corner School, and when George H. Moody purchased it, it became the Moody School. This section, adjacent to the Ogunquit River, was known as the Ogunquit section of Wells. As late as 1856 the map shows that the Ogunquit Post Office was still located here.

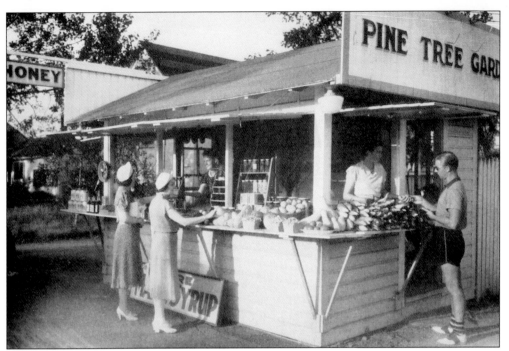

THE PINE TREE GARDEN. Farm stands sprang up along Route One in the 1920s. Doris and Joe Houston began this successful operation in 1928, and they quickly became known for their superior fruits and vegetables. Doris initiated the Toy & Gift Shop in 1938. Today's Pine Tree Garden is on the site of the original gift shop. The initial farm stand was located a few hundred yards north.

SHADY NOOK FARM. Another market garden and dairy farm was operated by Leon Goodwin at this location. The farm delivered to local folks at home as well as to the beach in the summer. Outdoor World is at this location now.

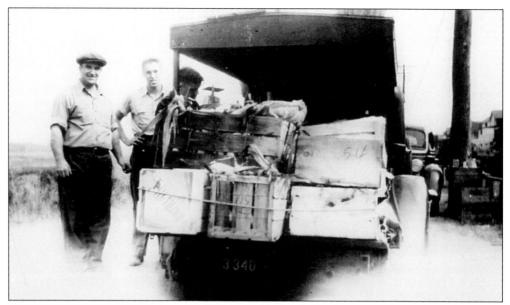

DELIVERING PRODUCE. Leon and his son, Richard Goodwin, are shown here delivering their summer produce from the back of their truck.

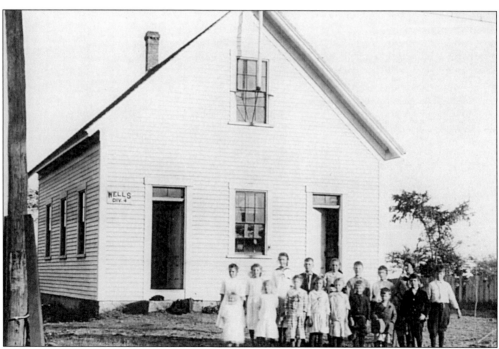

DISTRICT NO. 4, THE MOODY SCHOOL. This 1914 photograph shows, from left to right: (front row) Elizabeth Bourne, Ida Mae Bourne, Edith Moulton, Gladys Hilton, Marion Kimball, Charles Bourne, Eugene Littlefield, Jesse Moulton, and Charles Joy; (back row) Alice Moody, Bernice Bourne, Marion Littlefield, Hartley Hilton, Evelyn Bourne, Norris York, and Harold Littlefield. The teacher is V. Mae Harendeane.

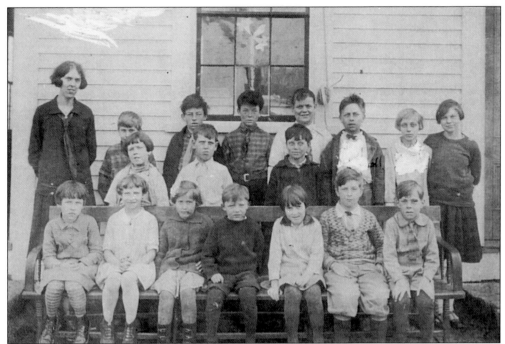

DISTRICT NO. 4, THE MOODY SCHOOL. This 1927–28 photograph shows, from left to right: (front row) Virginia Moody, Eleanor Galeucia, Mildred Adams, Gordon Galeucia, Marion Huckins, Meredith Norman, and John Huckins; (middle row) Olive Kimball, Floyd Butler, and Clarence Boston; (back row) Althine Munsey (teacher), Nelson Adams, Andrew Clogston, Woodbury Clogston, Clyde Fitzgerald, Paul Kimball, Bertha Bourne, and Etta Stewart.

RUTLEDGE ANTIQUES. Adjacent to the schoolhouse, this antique shop was operated by Helen and Wesley Rutledge in the 1930s. Jake's Seafood is now located on the site.

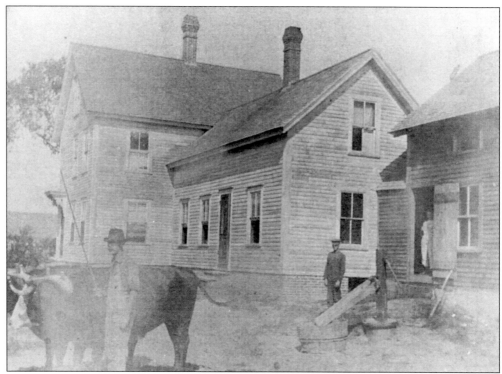

THE JONATHAN BOURNE FARM. This farm was located on the south side of Bourne Avenue, where the Wells Moody Motel is today. Moses Bourne is shown here with a team of oxen. When a young man, Moses participated in a cattle drive from Wells to Alton Bay, New Hampshire, to secure summer pasturage for the cattle.

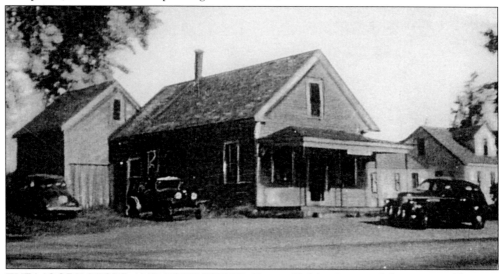

THE MOODY STORE AND POST OFFICE. George H. Moody owned this store and became the postmaster here in 1897. He served as postmaster for forty-three years. His daughter-in-law, Delia Moody, replaced him in 1940 and served until her retirement in 1960. The store and post office continued here until the brick building replaced the post office in 1975. The Wells Chamber of Commerce is at this location today.

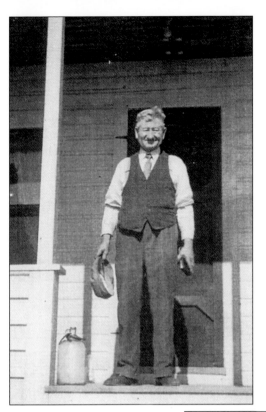

GEORGE H. MOODY (1869–1952). Mr. Moody not only was postmaster but he also took orders for his store and delivered them when necessary. He is shown here leaving a delivery at the beach.

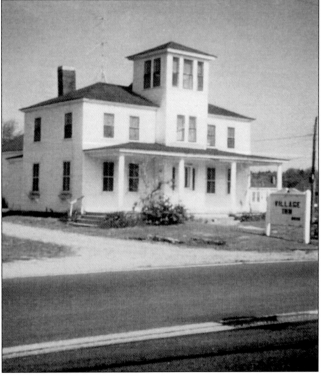

THE VILLAGE INN. This inn was also known as Unity Inn at one time. In 1872 Mrs. H.A. Littlefield owned this property. When school lunches began, the kitchen here was utilized to prepare lunches for the Moody School. Located at the south corner of Kimball Lane, this building was demolished, and Hayloft Restaurant is now on the site.

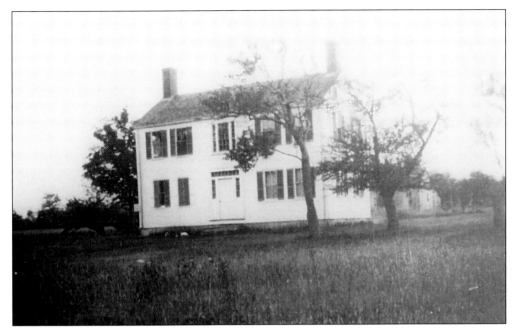

THE JOHN "EATON" LITTLEFIELD HOUSE. This house was built in 1814 by John's father, Nathaniel. It has been known to the community as the Holiday House since 1931. Many visitors have enjoyed their stay here; First Lady Eleanor Roosevelt is undoubtedly one of the better known.

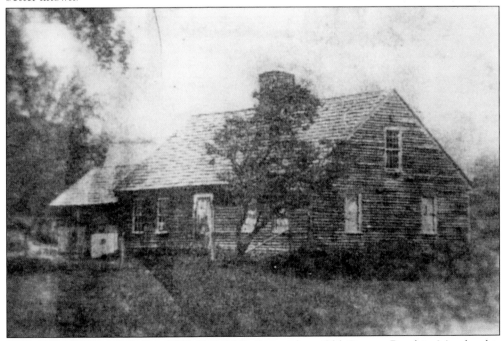

THE ORIGINAL KIMBALL HOMESTEAD. Located on Old County Road in Moody, this 150-acre farmstead was given to Caleb Kimball by his father-in-law, Nathaniel Cloyes, in 1715. Although this house no longer stands, five great-grandsons later, another Caleb Kimball resides on the original acreage.

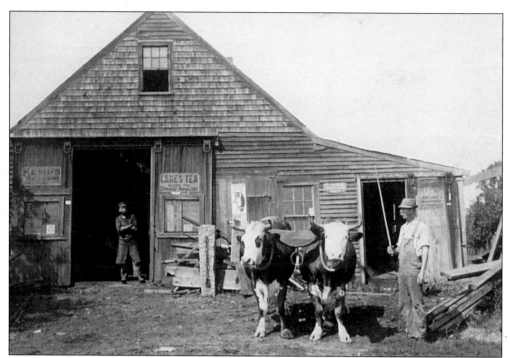

HURD'S BLACKSMITH SHOP. Each of the individual settlements within the town of Wells had a blacksmith shop. This one in Moody was located just north of the Holiday House on the west side of Post Road. Frank Kimball stands with a pair of steers in front of the building.

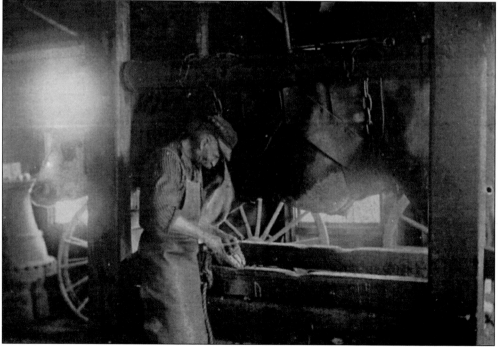

THE INTERIOR OF HURD'S BLACKSMITH SHOP. Charles Hurd is at work preparing to shoe an ox.

THE WILLIAM MOULTON HOMESTEAD. William Moulton was a shipwright and his shipyard was located behind his house on the banks of the Ogunquit River below the lower falls. Twenty-one vessels were built at this site between 1832 and 1871. The largest was the bark *Elm City* at 284.28 tons, and the smallest was the schooner *Volant* at 54.57 tons. Although the shipyard no longer exists, his homestead still does and today is occupied by one of his descendants.

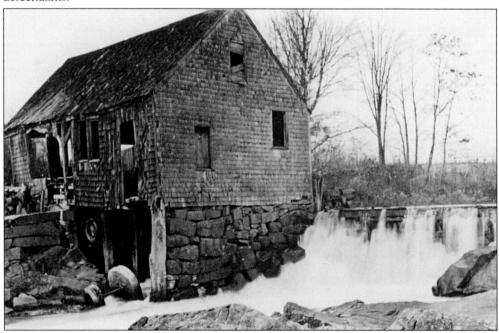

THE SAWMILL AT THE LOWER FALLS ON THE OGUNQUIT RIVER. This was known as the Donnell Mill when William Moulton had his shipyard. William married one of the Donnell daughters and his in-laws lived next door adjacent to the river. Today the Ogunquit Plantation is on that site.

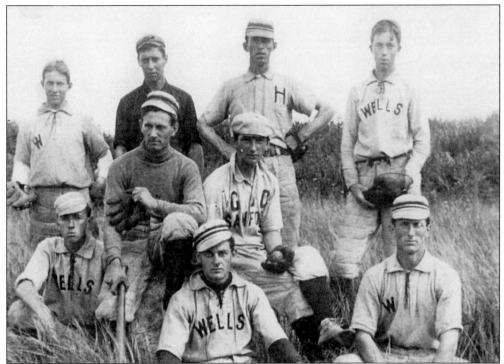

AN EARLY WELLS BASEBALL TEAM. Young men at the turn of the century were already involved in the "national pastime." From left to right are: (front row) George Devoe and Lester Kimball; (middle row) Charles Kimball, Hugh Pinkerton, and Earl Eaton; (back row) Russell Kimball, Guy Welch, George Burdett, and Bert Spiller.

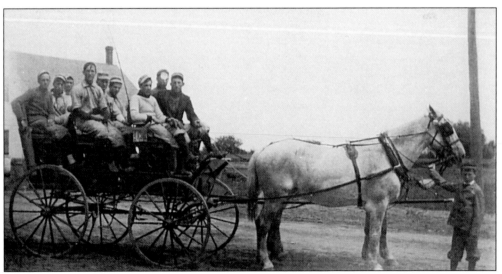

A BASEBALL TEAM EN ROUTE TO YORK. In 1897 horse-drawn buggies were the conveyance of the day.

Six

School District No. 6

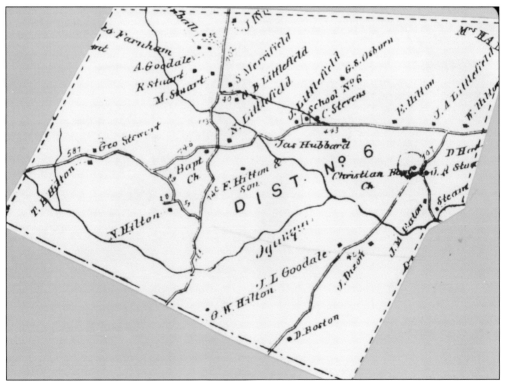

DISTRICT NO. 6, THE NORTH VILLAGE/STEVENS SCHOOL. This district encompassed the settlements adjoining Tatnic Road. It extended north from the present-day turnpike to the so-called Tatnic Hill area. It was called the Stevens District after 1900 when George Stevens replaced Woodbury Hilton as the agent for the school. Most likely the land that the school sat on was donated by a Stevens. It is located at the intersection of Hilton Lane and Tatnic Road.

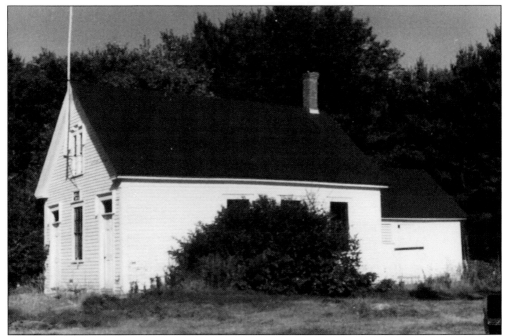

DISTRICT NO. 6, THE STEVENS SCHOOL. This typical one-room school was built in 1898 and served as the local elementary school until 1949. If a rural school failed to maintain an average attendance of eight pupils, it was automatically closed. The remaining pupils were bused to other districts.

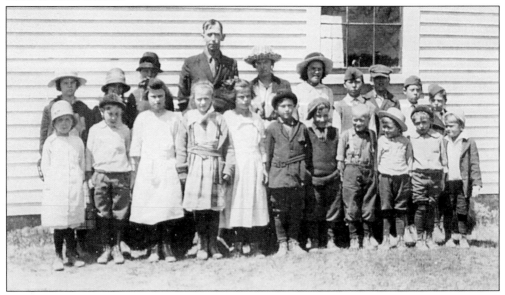

SCHOOL DISTRICT NO. 6. Grover Cheney was the teacher when this 1922 photograph was taken. The pupils are, from left to right: (front row) Marjorie Stevens, Clifford Hilton, Olive Hilton, Elsie Littlefield, Edna Hilton, Kenneth Hunt, Clyde Dixon, Howard Littlefield, Homer Stevens, Philip Hilton, and Archie Hilton; (back row) Lillian Hilton, Elizabeth Sherburne, Eva Littlefield, Ruth Hilton, Esther Hilton, Loveston Goodale, Levi Hilton, Leon Goodale, and Donald Goodale.

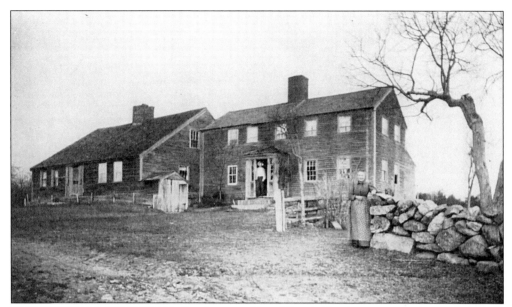

THE HILTON FARMSTEAD. On the east side of Tatnic Road, two generations resided side by side. The Cape-style home on the left has been replaced. Joshua Hilton is standing in the doorway of the building on the right and his wife, Elmeda, stands by the gate in this turn-of-the-century photograph.

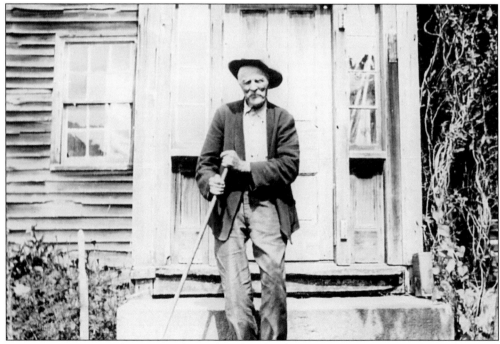

JOSHUA HILTON (1842–1937). A few decades later Joshua Hilton stands in the same doorway shown in the previous picture. A great-grandson of Joshua now resides on the adjoining property.

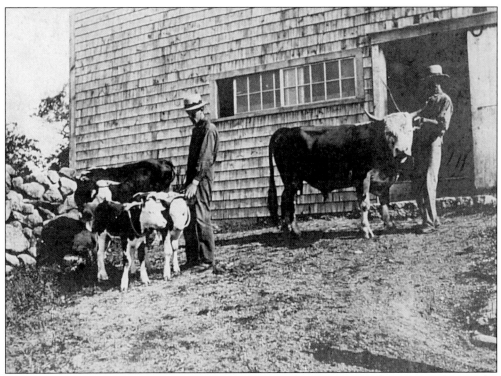

THE TATNIC ROAD/HILTON FARM. Brothers Fred and Lucien Hilton are tending to the animals in front of the family barn. The barns for the farmstead were located on the west side of Tatnic Road on the opposite side of the road from the house.

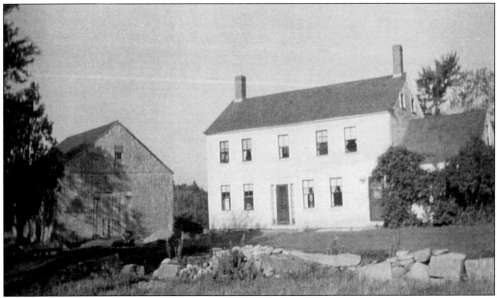

THE LITTLEFIELD HOMESTEAD. This farm is located on the west side of Hilton's Lane. The house was probably built in the 1830s by Nathaniel Littlefield. On the 1872 map a George Littlefield appears to be the owner. Clarence Littlefield was the last of the family to reside at this location.

Seven

School District No. 7

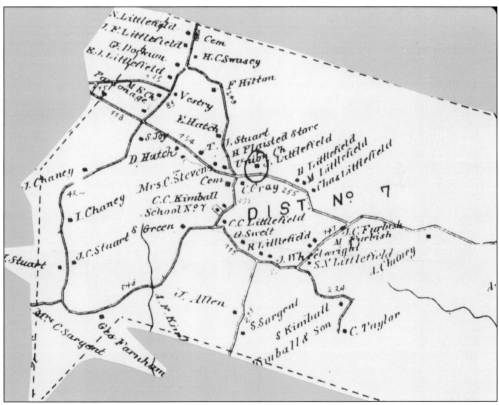

DISTRICT NO. 7, THE GRAY'S CORNER SCHOOL. This district included the settlements on Littlefield Road (9B) above the current turnpike, including Loop, Green, Cheney Woods, Bears Den, and Merriland Ridge Roads. In 1872 the school was located on Loop Road but it was later moved to 9B. Both locations were close to the intersection where the Gray family lived—hence the name.

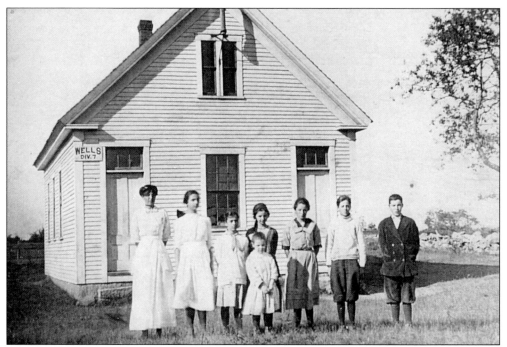

DISTRICT NO. 7, THE GRAY'S CORNER SCHOOL. Most of the school buildings had similar one-room designs. The agent for the district was responsible for maintaining the building, obtaining firewood for the wood stove, and hiring the teacher. Unfortunately the names of these students and teacher are not available.

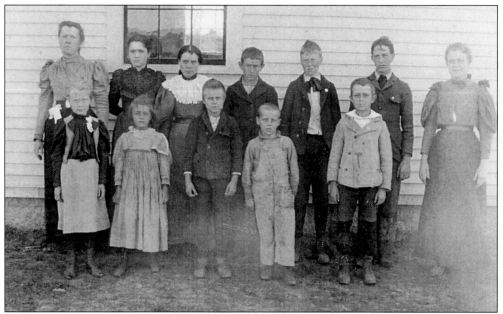

DISTRICT NO. 7, THE GRAY'S CORNER SCHOOL. This class was photographed in 1898. From left to right are: (front row) Mariun Littlefield, Flossie Littlefield, Lonnie Littlefield, Milton French, and Chester Furbish; (back row) Miss Annie Perkins (teacher), Argie Littlefield, Alice Cheney, Fred Furbish, Perley Gray, Arthur Littlefield, and Millie Littlefield.

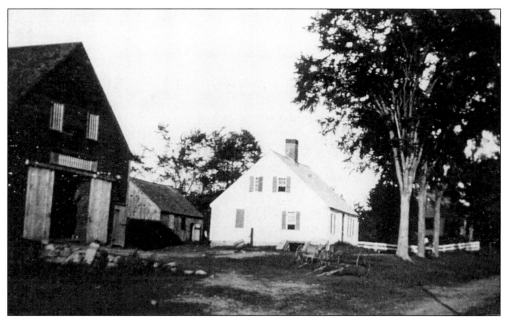

THE LITTLEFIELD FAMILY FARMSTEAD. This turn-of-the-century photograph depicts a working farm. This land, granted to the Littlefield's in the 1640s, remained in the Littlefield family until 1940.

THE LITTLEFIELD TAVERN. This Cape-style building, now on the National Register of Historic Places, was reportedly an early tavern and has large fireplaces (with bake ovens) in both front rooms. It is located on the north side of Littlefield Road (9B). Cleared fields and the homes located at Gray's Corner can be seen in the distance.

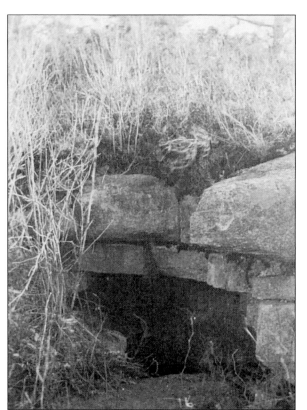

THE BEAR'S DEN. Bears Den Road is named after this natural phenomenon nearby where brother bruins actually do hibernate. Recent sightings confirm that the site is still in use after more than a century.

THE LITTLEFIELD FARMSTEAD AT MERRILAND RIDGE. In this turn-of-the-century photograph Albra W. Littlefield stands by his Morgan horse. Sarah Abby, his wife, is to the right of the front door.

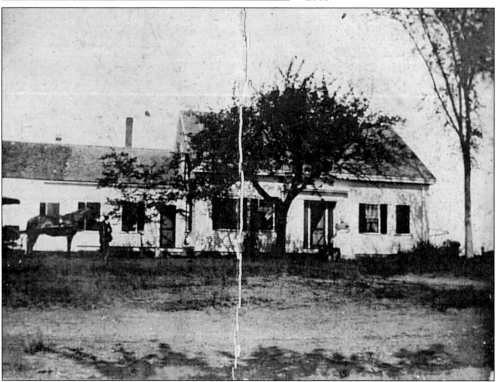

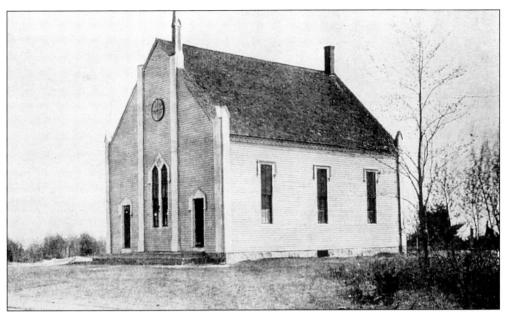

THE MERRILAND RIDGE MEETING HOUSE. The Methodist church at the "Ridge" was organized in 1851. The society merged with the Second Congregational Church of Wells in the 1940s. This meetinghouse was moved to Newfield, Maine, to replace the church there that had been destroyed in the 1947 fires.

REVEREND AND MRS. GEORGE D. STANLEY. Reverend Stanley was the pastor of the Merriland Ridge Meeting House in 1901–02.

MR. AND MRS. JOSHUA WHEELWRIGHT. Descending from Reverend John Wheelwright, Wells' first pastor, Joshua was one of the last of that surname to reside in Wells.

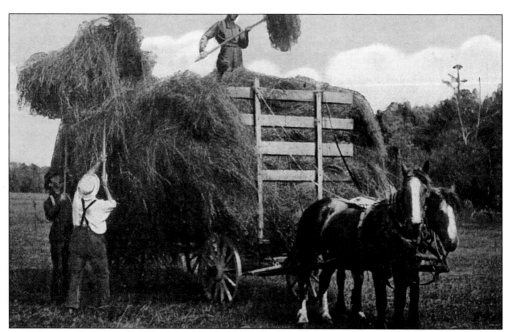

HAYING SEASON. Before machinery became available to farmers, haying season was a monumental task. Neighbors helped neighbors to facilitate this activity, which was necessary if the farm animals were to survive the winter months.

Eight

School District No. 8

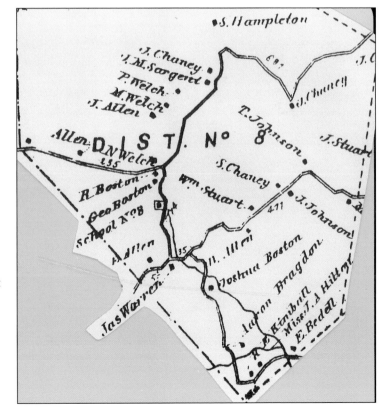

DISTRICT NO. 8, THE TATNIC SCHOOL. This district covered the upper Tatnic, Tatnic Hill, and Cheney Woods Roads. Frequently the winter term of school was not held in this district. Some families closed their farms, rented a home in North Berwick, and worked at the mills there during the winter months.

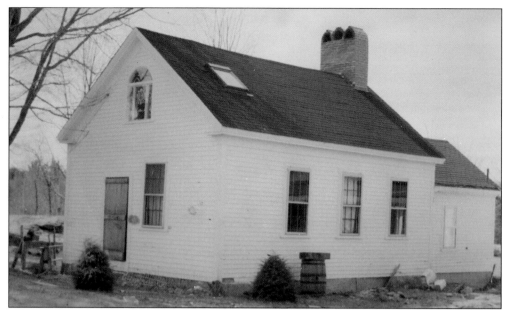

DISTRICT NO. 8, THE TATNIC SCHOOL. This school had already been converted to a private residence when this photograph was taken. It was located on the west side of Cheney Woods Road where it intersects with Tatnic Road. A previous school in this district was located further south on Tatnic Road.

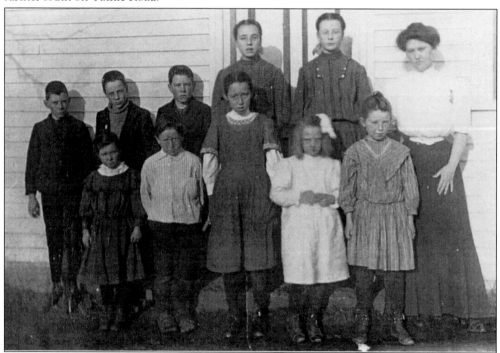

THE TATNIC SCHOOL IN THE FALL OF 1907. From left to right are: (front row) Stella Tufts, Walter Allen, Henrietta Allen, Dassy Kimball, and Marguerite Allen; (back row) Kenneth Tufts, Arthur Allen, Delbert Tufts, Lizzie Allen, Gertie Kimball, and Myrtle Hilton (teacher).

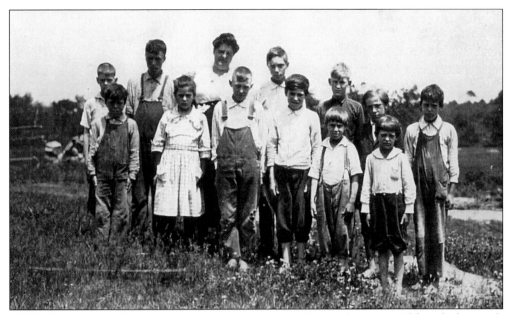

THE TATNIC SCHOOL. Mrs. Nellie Bedell is the teacher in this print. Although the pupils are not named individually, it is safe to say that they were children of the Tufts, Allen, and Kimball families. It is interesting to note that there is only one girl in this school photograph.

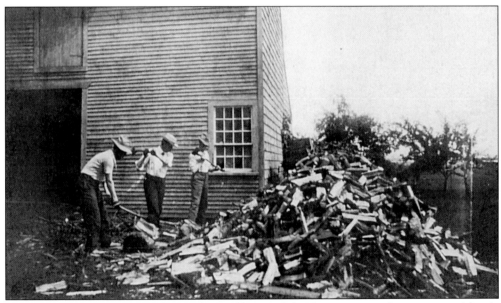

THE FARM WOODPILE. Splitting the wood to stack for the winter supply was a typical family chore. With each family having a wood lot, wood was the fuel of choice well into this century.

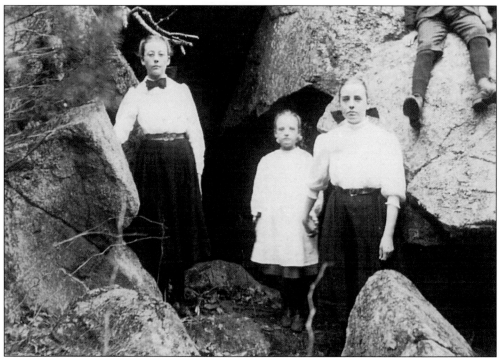

MORDAN'S CAVE AT TATNIC HILL. Gertie, Lizzie, and Dassy Kimball pose at the entrance to the caves. The caves were named for a family by the name of Mordan, who resided in these primitive conditions in the early 1700s. It is difficult to envision these accommodations, and even folks from the previous century wondered at the necessity of this depravation.

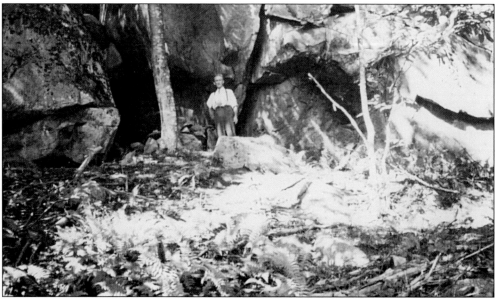

LESTER KIMBALL AT MORDAN'S CAVE. Natural rock formations from the glacial age created this cave.

HADASSAH "DASSY" KIMBALL (1832–1900). In 1874 "Dassy" lost her husband and three daughters to an unknown plague-type illness. With her remaining two boys and two girls she continued to manage the farm and pay off the mortgage. Her determination, hard work, and perseverance earned her the respect and admiration of not only her descendants but of all who knew her.

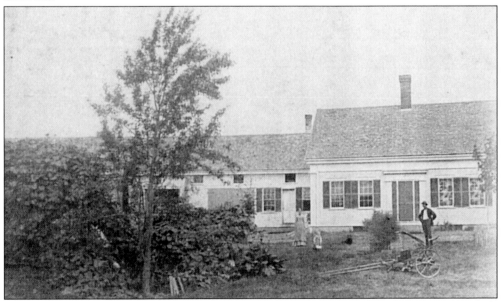

THE KIMBALL HOMESTEAD ON TATNIC ROAD. This turn-of-the-century photograph shows Ella and Frank Kimball in front of their home. Descendants still live at this location.

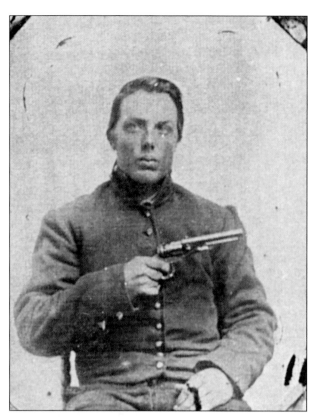

WALTER ALLEN (1840–1929). Walter is shown here in his Civil War uniform. He was a member of the 1st Maine Cavalry. Wounded at Boynton Plank Road in October 1864, he managed to crawl into a cave. Southern folks nursed him back to health. A fellow cavalry member from Wells, Joseph Eaton, escorted Walter back to Maine.

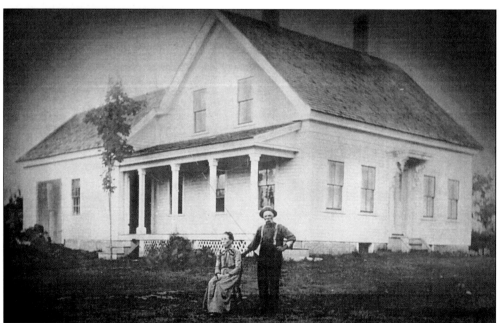

THE WALTER ALLEN HOMESTEAD ON TATNIC ROAD. This house originally stood on Tatnic Hill. It was moved by a team of twenty oxen to its current location on Tatnic Road. Walter and his wife, Margaret (Sargent) Allen, are shown here posing in front of their home.

Nine

School District No. 9

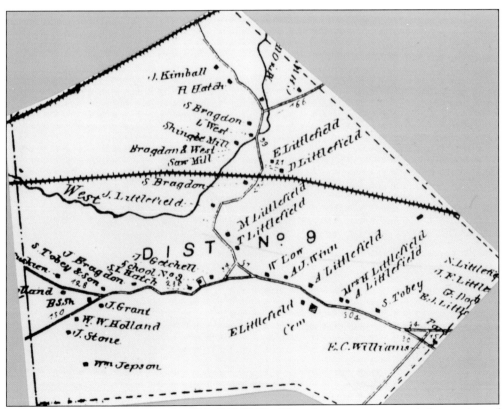

DISTRICT NO. 9, THE PINE HILL SCHOOL. This district encompassed the section of Berwick Road (Route 9) north of the Ridge, including Dodge, Bragdon, and Boyd Roads to the North and South Berwick lines.

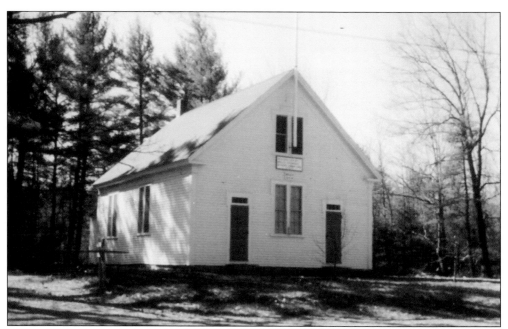

DISTRICT NO. 9, THE PINE HILL SCHOOL. This building, built in 1900, replaced the previous one located on the opposite side of the road. It was restored by the Wells Bicentennial Committee in 1976. It was then placed under the auspices of the Wells Preservation Committee and maintained by the town. It has just recently been placed on the National Register of Historic Places.

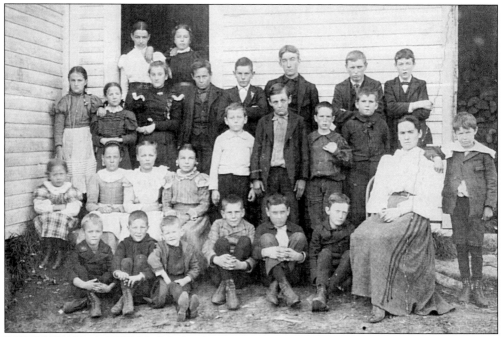

DISTRICT NO. 9, THE PINE HILL SCHOOL BEFORE 1900. This photograph was taken at the site of the previous school on the east side of Berwick Road. Unfortunately, the names of the pupils and teacher are unknown to us.

THE LYDIA LITTLEFIELD TAVERN. Built in 1812 by Joseph Littlefield, this tavern was maintained by his wife Lydia following his death. It was one of eight taverns in Wells in 1825 and served as a mail stop for the stages traveling from Dover, New Hampshire, to Portland. The folks in this photograph are, from left to right: Clara Littlefield, Ellen Littlefield (in the door), an unidentified boy, a man who may be the hired hand or Ed, and Aunt Huldah (sitting in the corner chair).

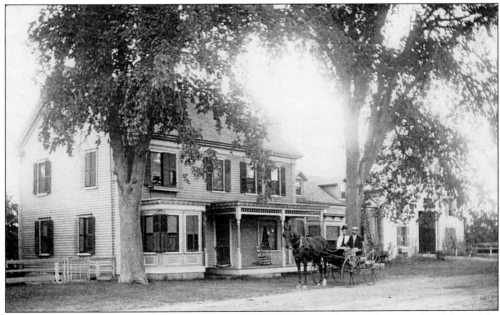

THE OSCAR LITTLEFIELD HOUSE. This house was on the northeast side of the Lydia Littlefield Tavern on Berwick Road. It was destroyed by a fire caused by an electrical short-circuit in the adjoining barn.

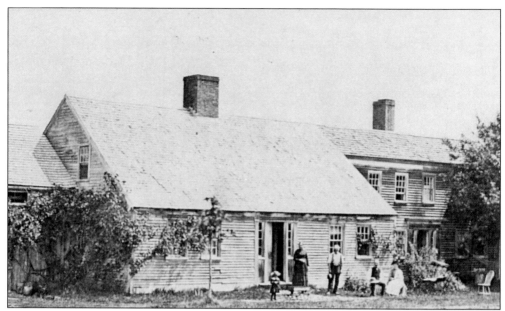

THE LITTLEFIELD FAMILY FARMSTEAD. The Cape Cod-style section was built in 1776, and the two-story ell was moved here from across the field when the old Berwick Road was straightened. This is one of fifteen Capes on the National Register of Historic Places in Wells. It has remained in the same family through many generations; Ray, Elizabeth, Alfred, Haven, and Ida (holding Guy) are shown here.

THE NICKOLAS LITTLEFIELD TAVERN. Located on the east side of Berwick Road, just north of the Littlefield Farmstead, this set of buildings was destroyed by fire when struck by lightning in 1917. This turn-of-the-century photograph shows Frank Littlefield, Prudence Winn, her half-sister Emily, Nora L. Lord, and Hazen Lord.

THE BRAGDON FARMSTEAD. Located on Bragdon Road adjacent to the B&M Railroad tracks and crossing, this was the original home of Sewall Bragdon. The Bragdon and West saw and shingle mill were located nearby on the West Brook. The Bragdons also owned a store nearby.

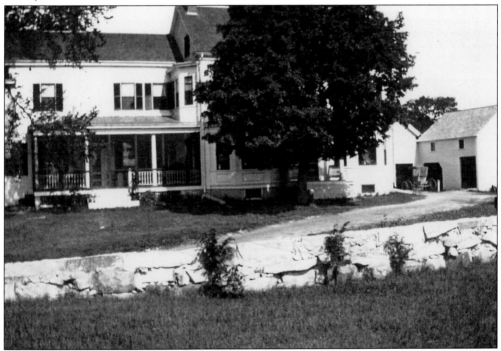

THE BRAGDON HOMESTEAD. This photograph shows the same house after it had been raised and a new first floor added, c. 1910–12. Descendants reside here still and manage the farm.

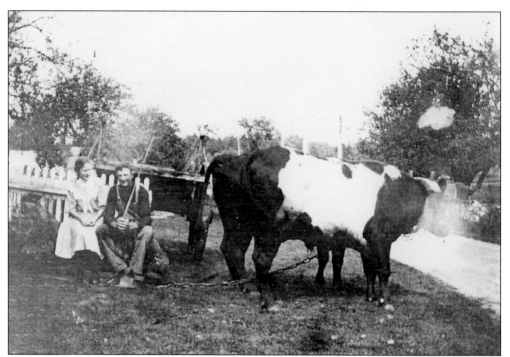

A SUMMER BREAK. Betty and Roger Bragdon, sister and brother, took a break for this photograph. The team of Holstein oxen was a part of their working farm. The Bragdons were all livestock dealers and traveled extensively to procure suitable animals for their clientele.

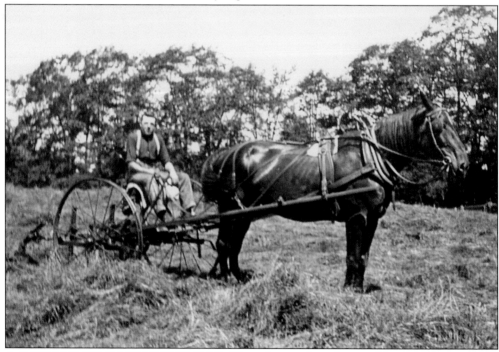

A FARM HAND RAKING THE HAY. The advent of machinery like the tedder greatly facilitated the haying process. This photograph was taken at the Bragdon Farm.

Ten

School District No. 10

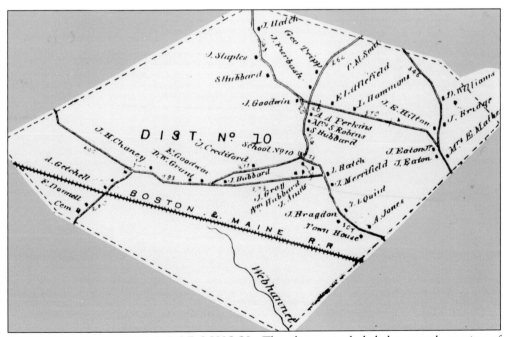

DISTRICT NO. 10, THE RIDGE SCHOOL. This district included the easterly section of Berwick and Crediford Roads, Sanford Road north of the current turnpike, and the westerly end of Branch Road.

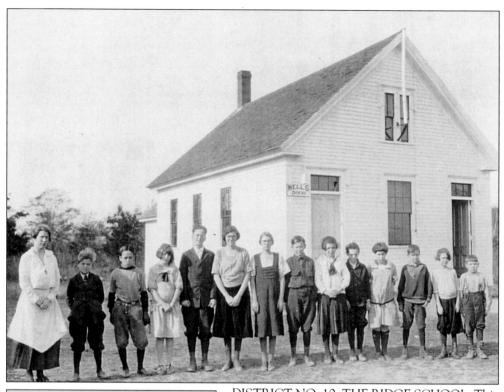

DISTRICT NO. 10, THE RIDGE SCHOOL. This schoolhouse was built about 1898, and serves as a private residence now. It is located on Crediford Road opposite the Nella Road intersection. Faye Weeks is the teacher in this 1922–23 photograph. Two of the boys are Tiltons but the others have yet to be identified. The Sawyer, Hill, Kenney, and Boyden families attended this school.

THE HEARD FAMILY CEMETERY. The legend is that Theodore "Thed" Heard, who died in 1833, was buried "sitting up"; having been confined to a wheelchair, he wanted to be buried that way. The marker at the top of the monument says: "Family Tomb of Daniel Heard–1815." Daniel's wife, Lydia, died in 1812, and Daniel himself died in 1822. "Thed" was their son.

Eleven

School Districts
No. 11 and No. 12

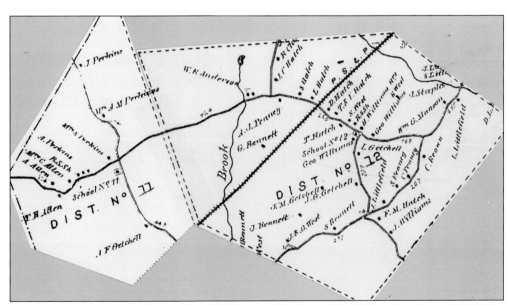

DISTRICT NO. 11, THE PERKINSTOWN SCHOOL; DISTRICT NO. 12, BALD HILL
SCHOOL. These districts included the Bald Hill, Perry Oliver, Horace Mills, and Quarry
Roads. These two districts merged when the number of students didn't warrant keeping the
school open. The District No. 11 school no longer exists, and the District No. 12 school is now
a private residence.

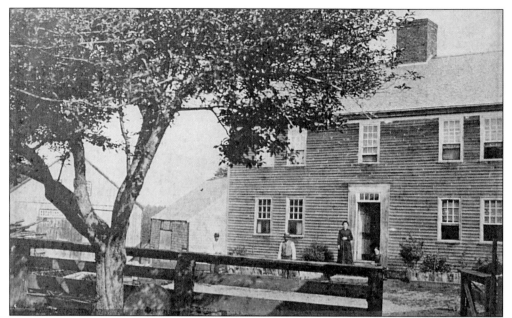

THE WEST FAMILY FARMSTEAD. This home was located on the west side of Bragdon Road just north of where Randolph West lives today. It burned in 1935. John and Lydia West are to the left of the front door in this turn-of-the-century picture.

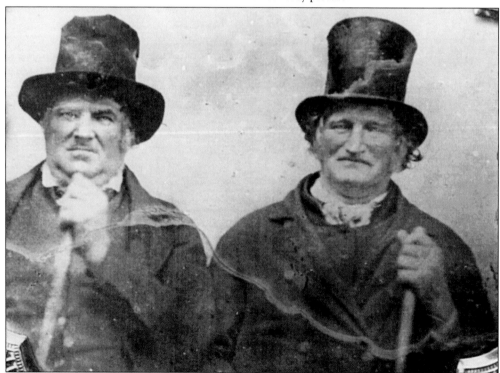

OLIVER AND JACK WEST. These brothers split the family home into a double residence with each living in one half. Oliver was the carpenter and blacksmith for the family enterprises while Jack did the farming.

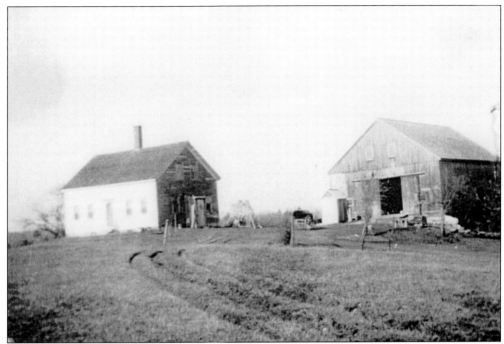

THE CARD FAMILY HOME. Captain Frank Card was a sea captain but farmed here when not at sea. His family included four daughters, who married into the Bourne, Kimball, Goodale, and Hutchins families. This house burned in the late 1800s.

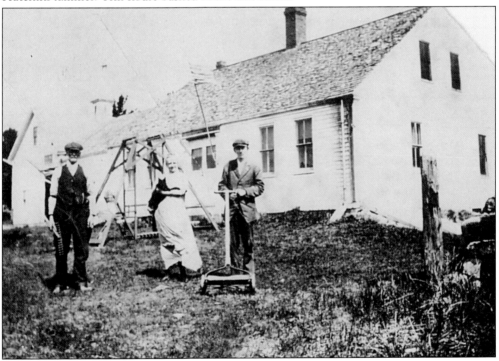

THE HATCH FAMILY HOME AT BALD HILL. Downing Hatch, a Civil War veteran, is shown here with his wife, Julia, and his son, Howard.

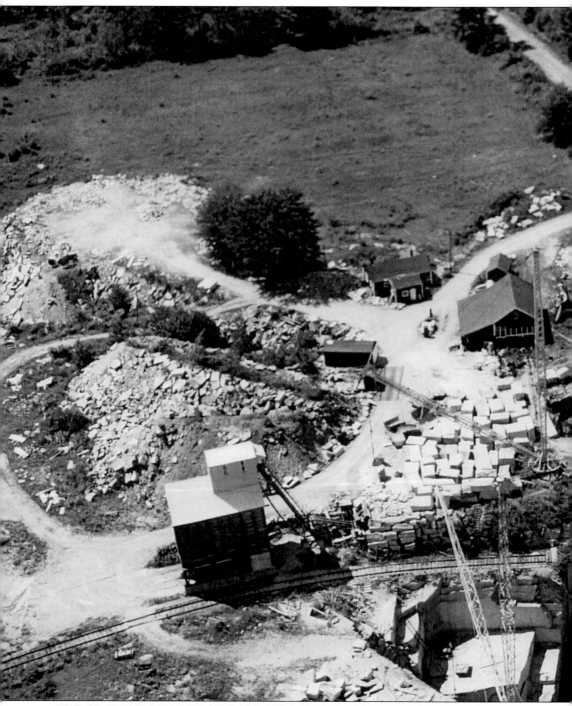

THE GRANITE QUARRY AT BALD HILL. Both the Miniutti and Swenson brothers have owned this operation. Not until well into this century, when power equipment facilitated the operation, did the mining industry really flourish. Wells' pink granite is found at Seagram's Plaza and the Tiffany Jewelry Store in New York City; the New Hampshire Savings Bank in Concord and the Federal Building in Manchester, New Hampshire; the State Mutual Insurance

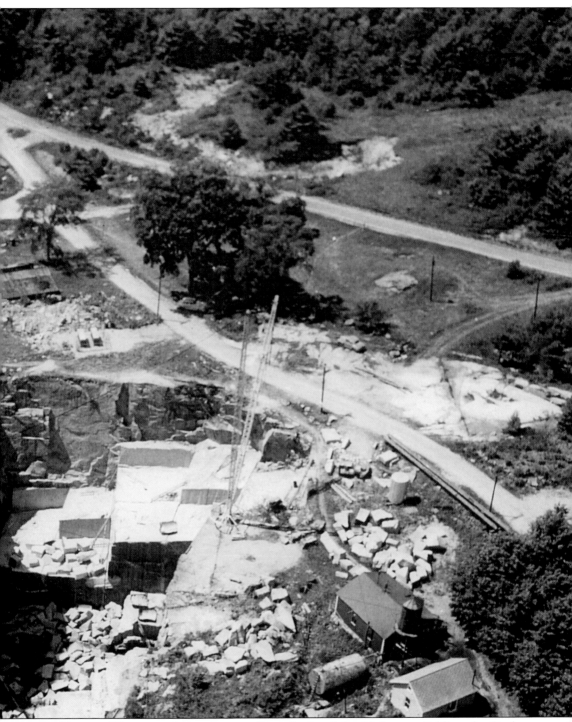

Building in Worcester, Massachusetts; The Tomb of the Unknown Soldier, the Rayburn Office Building, and the Hirshhorn Museum in the Washington, D.C. area; as well as the breakwater and jetty projects here in Wells. This operation provided employment for many local residents.

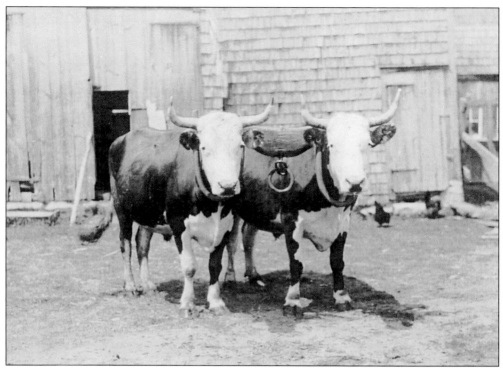

A LOCAL TEAM OF OXEN. Oxen provided the muscle for rolling the snow, moving buildings, and grading roads before the advent of snow plows, trucks, and loaders. Farmers often gave their animals names. One team was called Zechariah and Peter, probably shortened to "Zach" and "Pete" by their handlers.

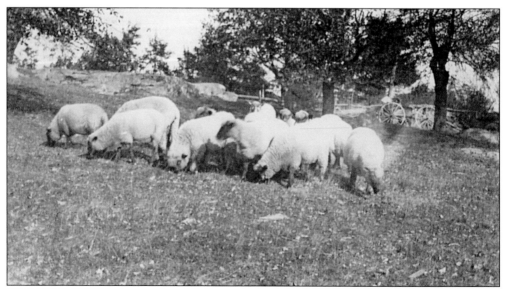

GRAZING SHEEP. Letters from Wells in the late 1600s to Massachusetts mention Indians driving away the sheep. Wool and mutton made sheep a valuable farm resource, even during the earliest settlement years.

Twelve

School District No. 14

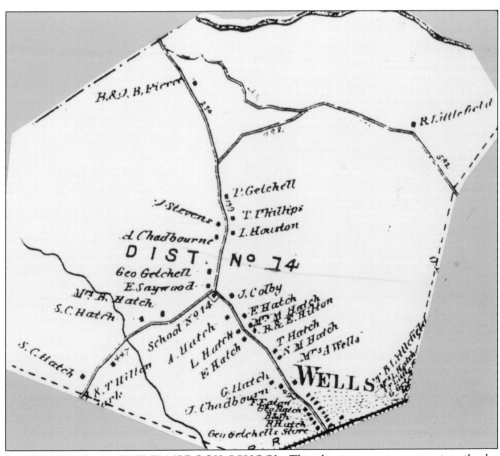

DISTRICT NO. 14, THE ELMBROOK SCHOOL. This district encompasses primarily the Highpine area (formerly Wells Depot) from the railroad on Sanford Road to the Sanford line.

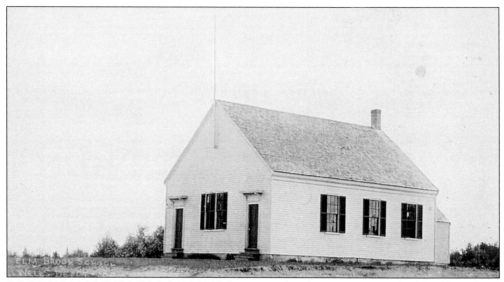

DIVISION 14, THE ELMBROOK SCHOOL. Located at the intersection of Bald Hill Road and the Highpine Loop, this school taught the Hatch, Hilton, Allen, Lord, Sayward, and Matthews families of this area.

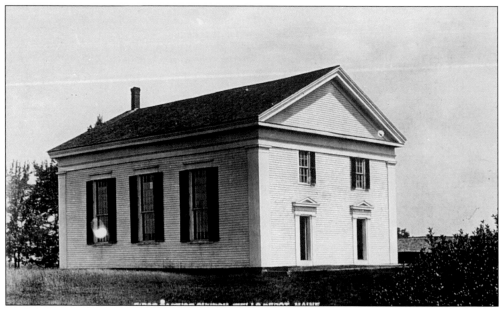

THE FIRST BAPTIST CHURCH, WELLS DEPOT. Erected in 1800, this church was located at the southeast corner of the intersection of Meetinghouse and Sanford Roads. The church burned in the early 1930s.

THE WELLS DEPOT STATION AND POST OFFICE. The Wells Depot station is on the left and the post office is in the building on the right. This is a view looking north as Sanford Road crosses the bridge over the Portsmouth, Saco and Portland Railroad. The depot was built *c.* 1842 when the railroad went through. Judson Hatch's store housed the post office.

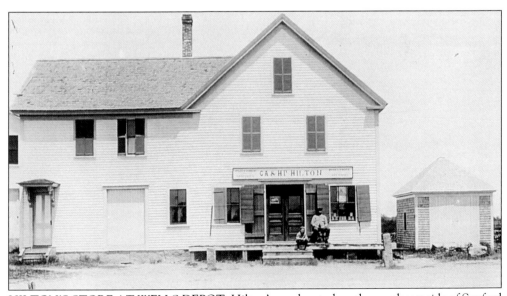

HILTON'S STORE AT WELLS DEPOT. Hilton's was located on the northeast side of Sanford Road north of the railroad tracks. The railroad was instrumental in naming the Wells Depot area. It also provided work and business for local residents.

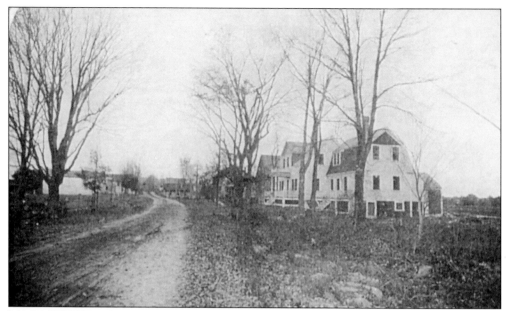

MAIN STREET, LOOKING NORTH, WELLS DEPOT. This turn-of-the-century photograph depicts the southerly end of the community. Wells Depot's name was changed to Highpine in the 1920s.

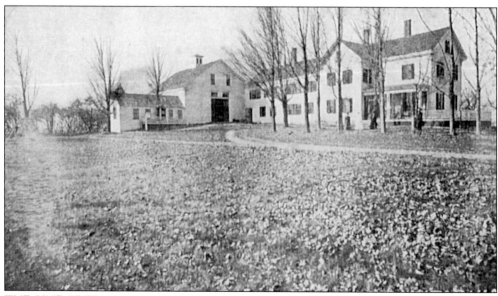

THE PINE TREE SANITARIUM. Advertised in 1911 as a health resort to relieve nervous disorders, it promoted the benefits of the soothing and quieting pine forests of Maine. Treatment consisted of special diets, hydrotherapy, electricity, vibration, and massage, all under the care of attending physicians. This facility now houses an apartment complex.

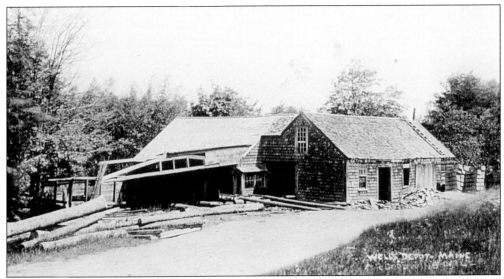

GOODWIN'S SAWMILL. This mill was located on the south side of the Merriland River, on the northeast side of Sanford Road at the north intersection of Sawyer Road. The 1872 map shows a gristmill at this location.

LUMBERING. Clarence and Karl P. Hilton are shown here with a load of lumber on their Model T truck.

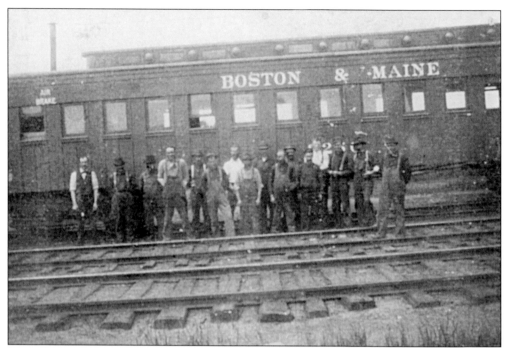

BOSTON & MAINE RAILROAD EMPLOYEES. This photograph shows the double sidings at the Wells Depot station. The only person identified is Ernest Matthews, the third from the left in the front row.

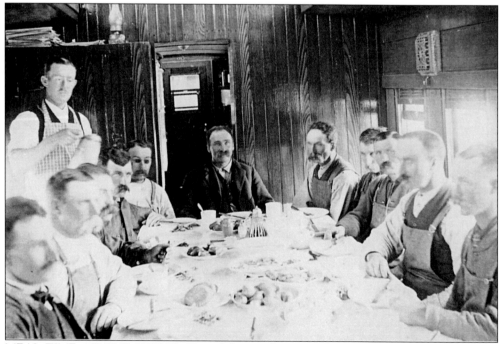

MEAL TIME AT THE SIDING. From left to right are: unknown, Willis Allen, unknown, unknown, unknown, Alvorado Hatch (head of table), unknown, Marcellus Donnell, Simon Hatch, Stephen Hatch, James Hatch, and John Jacobs (the cook).

Thirteen

School District No. 16

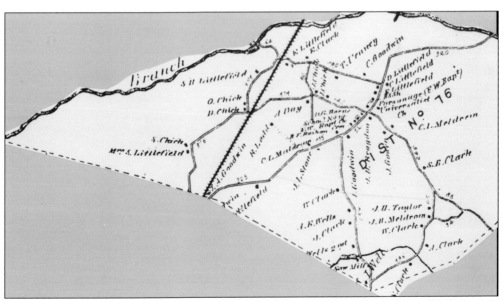

DISTRICT NO. 16, THE BRANCH SCHOOL. This area covers all of what is Wells Branch today: the Branch, Clark, Chick's Crossing, Hobbs, Cole's Hill, and Mildram Roads, and the east end of Meetinghouse Road.

DISTRICT NO. 16, THE BRANCH SCHOOL. This school was located on the north side of Branch Road at the intersection of Clark Road. The District 15 building was added when that school closed. The building now houses the Wells Branch Fire Company.

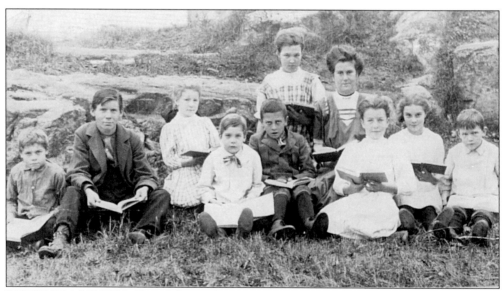

DISTRICT 16 PUPILS. From left to right are: Loring Smith, Merton Littlefield, Faye Weeks, Willis Gowen, Carl Goodwin, Flo Weeks, Phoebe Gowen, Harold Littlefield, Hazel Littlefield, and their teacher.

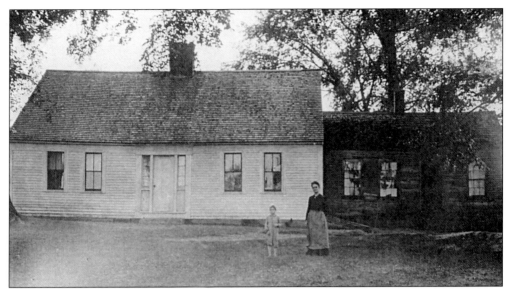

THE GOWEN HOMESTEAD. Located on Chick's Crossing Road, this homestead is still in the Gowen family. Willis and his mother, Eva (Usher) Gowen, are shown here in front of the house.

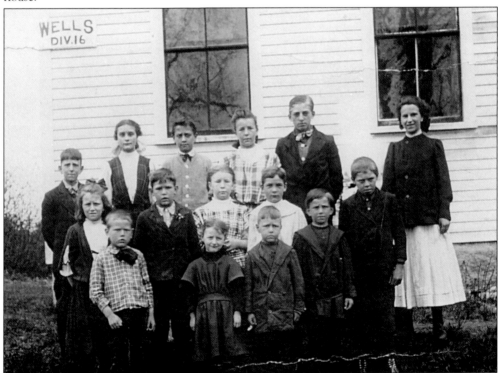

DIVISION 16, THE BRANCH SCHOOL. Instead of districts, the schools were called divisions after the turn of the century. From left to right are: (front row) Waldo Chick, Minnie Welch, unknown, unknown, and Loring Smith; (middle row) Ruth Farnum, Harold Littlefield, Faye Weeks, and Willis Gowen; (back row) unknown, Phoebe Gowen, Carl Goodwin, Ruby Hill, and Howard Fenderson.

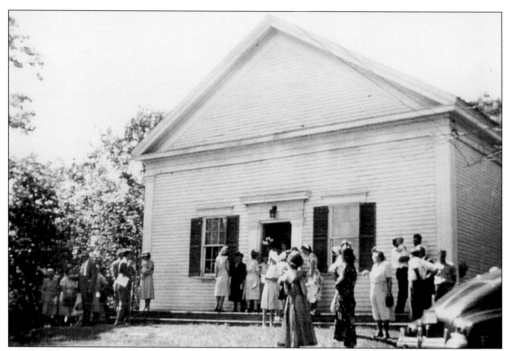

THE WELLS BRANCH BAPTIST CHURCH. Originally organized in 1814 as the Independent Christian Baptist Society, by 1838 it was called the First Free Baptist Parish. This society and church are still active today.

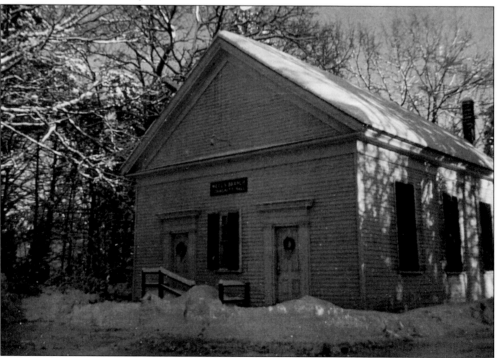

THE WELLS BRANCH COMMUNITY LEAGUE BUILDING. Built in 1862 by the Universalist Society, it was used for summer services and disbanded before 1930.

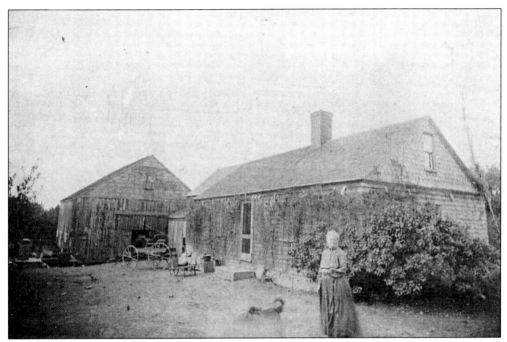

THE CLARK HOMESTEAD. This building was located on Clark Road. Sarah (Tudor) Clark stands in front of her home. Charles H. Clark was her husband, and Charles M. Clark, her son.

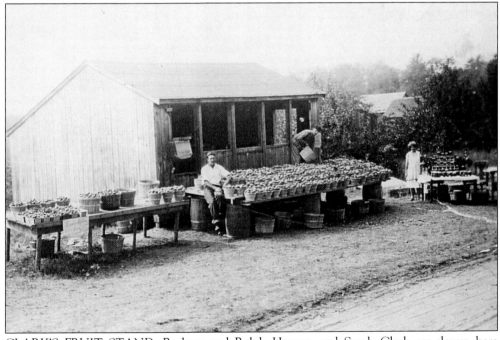

CLARK'S FRUIT STAND. Rodney and Ralph Hanson and Sarah Clark are shown here tending to sales. Charles M. Clark's orchards were known worldwide as his apples were shipped as far as Cairo, Egypt. With over one thousand trees, he was able to provide for the fifteen hundred customers who sought his product annually.

THE JOSHUA CHICK HOMESTEAD. Joshua Chick kept Chick's Store to accommodate local residents. He also donated land when the railroad came through.

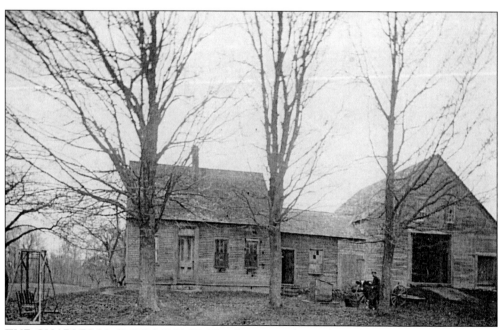

THE CHARLES H. SMITH HOME. This home was located on the easterly side of Branch Road, a few yards north of the Hobbs Road intersection.

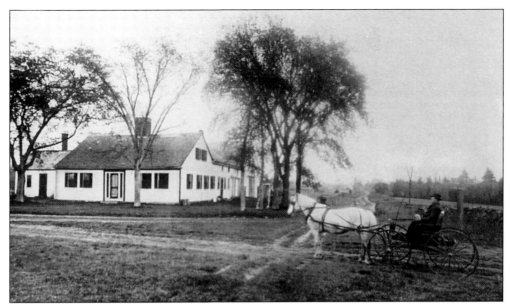

AN EARLY HOMESTEAD. Located at the north corner of the intersection of Burnt Mill and Branch Roads, this house is one of fifteen Capes on the National Register of Historic Places in Wells. It is situated directly opposite Recreation Field.

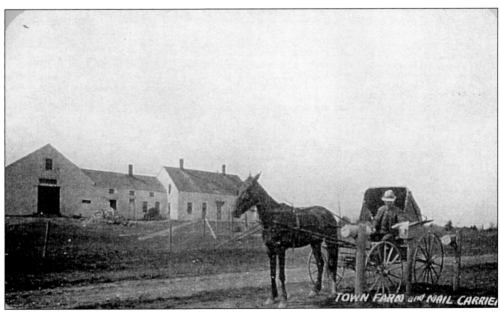

THE TOWN FARM AND A MAIL CARRIER. The Town Farm provided residents with work and a home when they had neither. Located on the site of Recreation Field, it burned c. 1912. In 1896 provisions were made for the rural delivery of mail. This carrier, making deliveries, is probably Herbert "Bert" Wells.

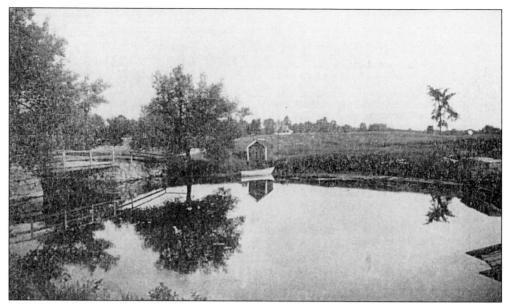

STORER POND. This pond is located on today's Hobbs Road, formerly Burnt Mill Road. The mill that burned was located on the falls by the pond. During the middle of this century, the pond was a local "swimming hole" in the summer and a skating area in the winter.

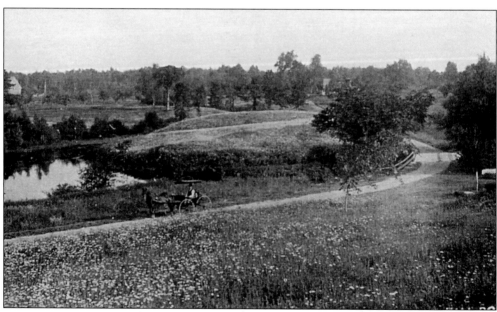

BURNT MILL ROAD. This early school bus, driven by George Forbes, transported students to Division 1 or 2 schools.

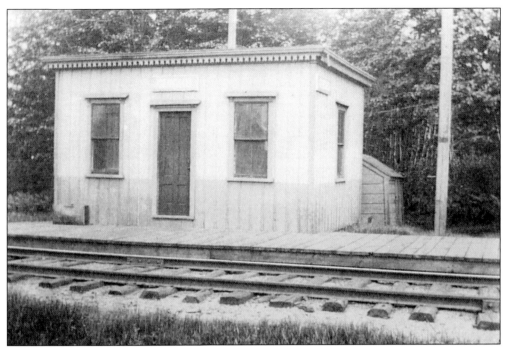

CHICK'S WELLS BRANCH STATION. The Portsmouth, Saco and Portland Railroad named this station, located at the intersection of Clark and Chick Roads, after its station master, to differentiate between the stations at Wells Depot and Wells Beach.

A TRAIN AT CHICK'S CROSSING. Today's Chick's Crossing Road derives its name from this location. Located just north of Willis Gowen's house, the railroad bed is still visible.

MERRILAND CAMP. Located on Cole's Hill Road, this camp operated during 1919–20. Every two weeks, young ladies would vacation here. A dance hall encouraged local young men to entertain the young ladies. Facilities included a cement swimming pool in the Merriland River.

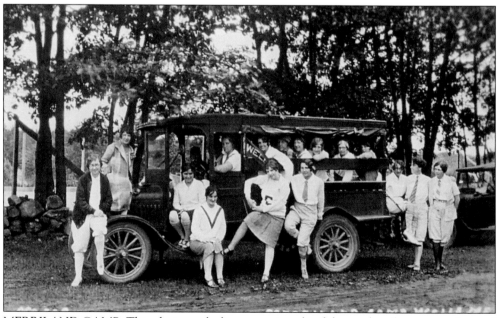

MERRILAND CAMP. This photograph shows an example of the modes of transportation and the styles of dress as the country rebounded from World War I.

Fourteen

Along the Shore

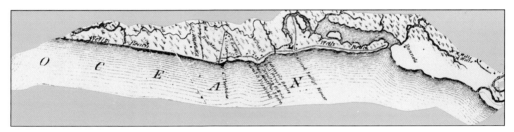

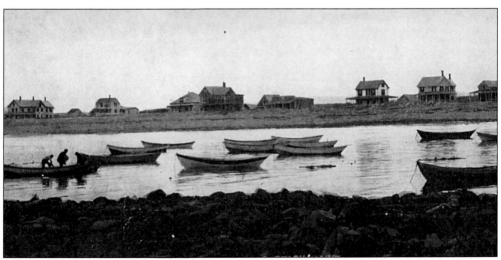

LIFE ALONG THE SHORE. The Webhannet River, the marshes, the harbor, and Fishermen's Cove (bottom photograph) were the mainstay of existence for residents when farm products were in poor supply. Wooden dories were used at the turn of the century by local fishermen. These were 14 to 16-foot boats with oars and a sail. With this minimal equipment local fishermen battled the sea and the elements to secure their catch.

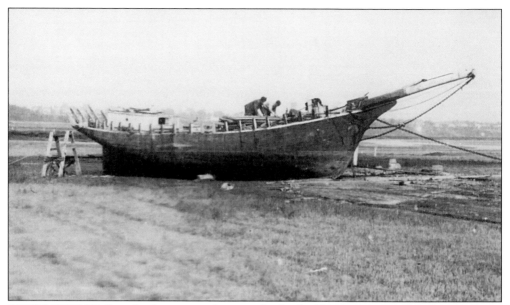

SHIPBUILDING. Riverbanks were used as sites for shipbuilding, a business that thrived during the age of sail. Schooners were the workhorses of the sea lanes. They carried wood and lumber products from Wells, and returned with supplies for the merchant ship owners.

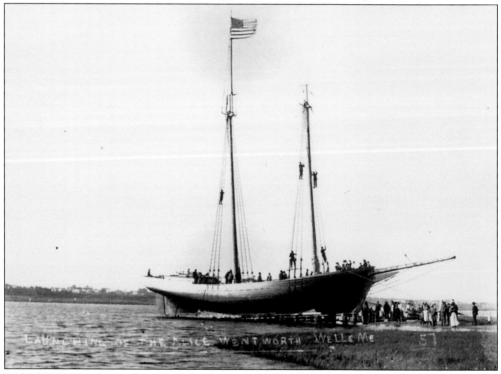

LAUNCHING. Originally named the *Lizzie A. Tolles*, this schooner was rebuilt from stem to stern when it was forty years old. With new documentation, Captain Stephens rechristened it the *Alice S. Wentworth*, after a favorite niece. This launching occurred in 1904 on the banks of the Webhannet River.

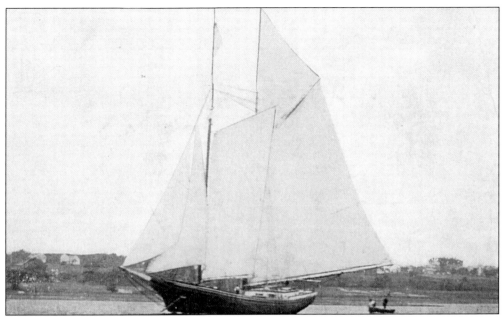

THE SCHOONER *ALICE S. WENTWORTH*. Under full sail, the *Wentworth* heads toward the wharf on the Mile Road. Captained by Zeb Tilton, the *Wentworth* earned recognition as the smartest, slipperiest coaster afloat. No schooner of equal size ever outsailed her.

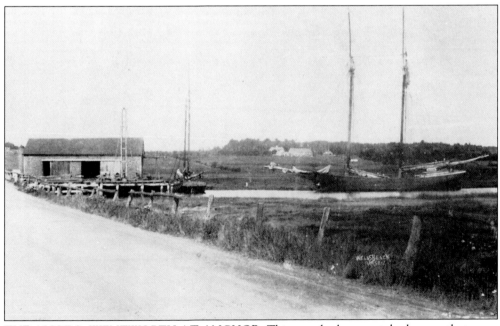

THE *ALICE S. WENTWORTH* AT ANCHOR. This was the last coastal schooner that came regularly into Wells (it did so until the 1920s). Its outgoing cargo was lumber, its incoming coal. An unidentified vessel sits next to the wharf.

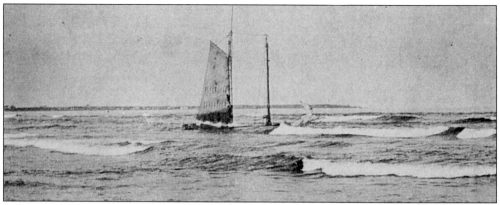

A SCHOONER AGROUND AT THE MOUTH OF THE WEBHANNET RIVER. The schooner *William M. Walker* ran aground on September 11, 1914. The sand bar there is covered with only 9 feet of water at high tide and only 3 feet of water at low tide. Entering the harbor has always been a precarious venture. Ship logs note that they often waited at another port or "outside" for the high tide at Wells.

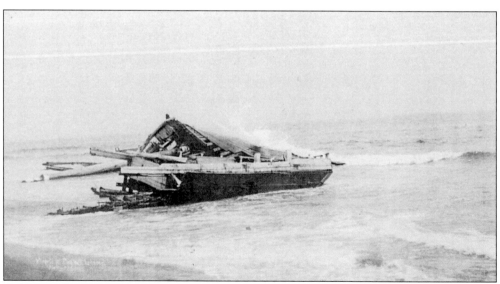

A SHIP WRECK ON DRAKE'S ISLAND. The beaches here have seen their share of ship wrecks over the three hundred and fifty years that coastal trade has ventured by. This unnamed vessel broke up on Drake's Island in 1906, spilling a load of coal.

THE SALT HAY MARSH. It has been written that every early settlement adjoining a salt marsh was able to thrive and prosper because livestock could be bred. Wells was one of those mentioned. This 1910 postcard shows the gathering of the marsh hay from a dory or skiff. The quality of marsh hay was exceptional because of its high mineral content.

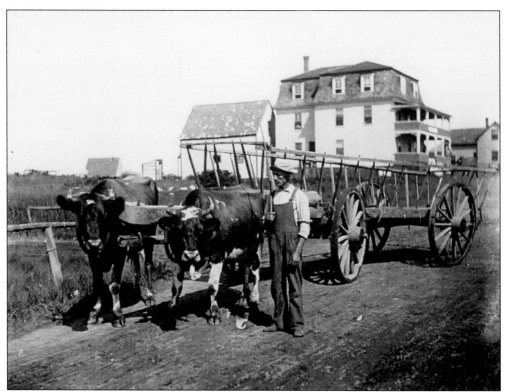

A TEAM OF OXEN WITH A HAY WAGON. The road nearby is called Ox Cart Lane. Undoubtedly this team will soon be hauling a load of marsh hay.

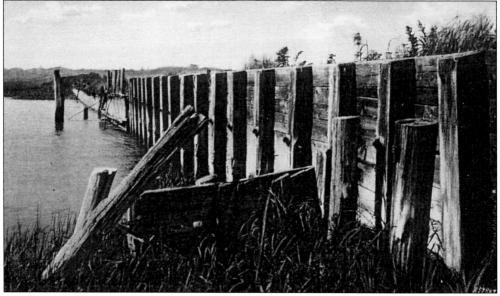

THE DIKE ON THE WEBHANNET RIVER. The dike was built in the late 1800s to control the tidal waters on the marshes and thus facilitate haying. All owners of adjoining marshlands were billed by the town for the costs of building the dike in 1892. Annual bills thereafter were submitted for the maintenance of the dike.

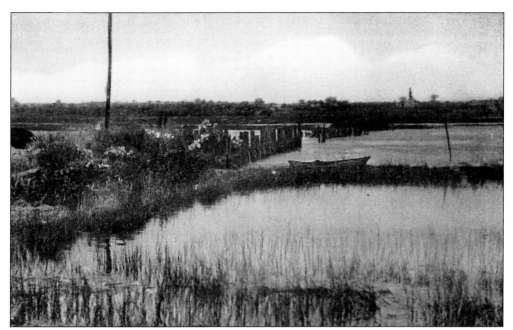

THE DIKE AND ADJOINING UPLANDS. The steeple of the Meetinghouse Museum can be seen to the right of the dike in this photograph. A dory is also tied up nearby. The remains of these pilings can still be seen at this location.

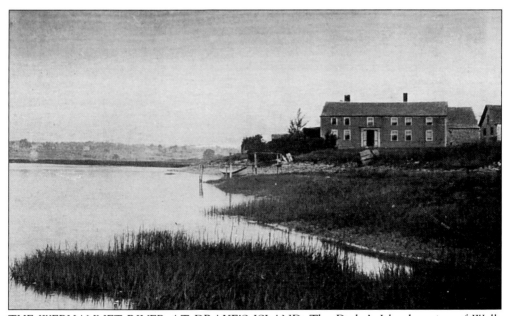

THE WEBHANNET RIVER AT DRAKE'S ISLAND. The Drake's Island section of Wells reportedly was named after Thomas Drake, an early Casco Bay trader who may have also traded here. The building on the right reportedly was an early warehouse located near the ocean-side wharves. It was moved back to this current location, and when the Eaton family purchased it, was called Eaton Croft.

JOSEPH D. EATON (1838–1916). Joseph Eaton was a Civil War veteran of the 1st Maine Cavalry. He purchased his house and all the land on Drake's Island in 1883 for $385. His home at Drake's Island was a showplace, with beautiful gardens surrounding his house. He was a civic-minded citizen who served as a local postmaster for a time and was also a state representative.

KATE FURBISH (1834–1931). Kate was an amateur botanist who visited at the Eaton Farm on Drake's Island. In 1898 she documented, in Wells, the only known location in Maine of the plant *Iris Prismatica Pursh*, also known as Slender Blue Flag.

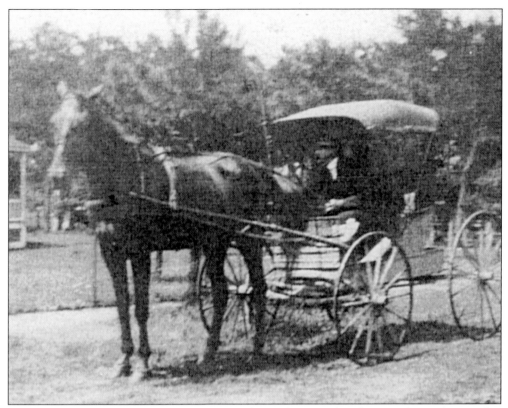

THE MAILMAN AT DRAKE'S ISLAND. The mailman in this photograph is unknown, but perhaps it is the same Bert Wells who delivered in other sections of town. Before the present Drake's Island Road was built in 1890, the island was reached by the so-called Beach Road (now Laudholm Road).

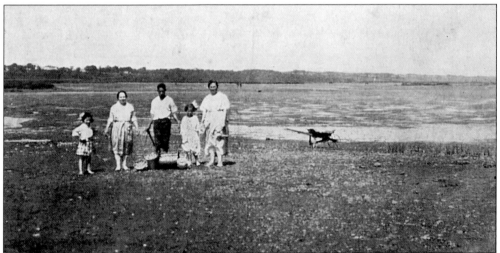

DREDGING CLAMS. Clams have always been enjoyed in Wells. Native Americans were known to have harvested clams, and they left piles of shells behind. Certainly they must have provided a readily-available food source for the early settlers. Here a family pauses while harvesting theirs.

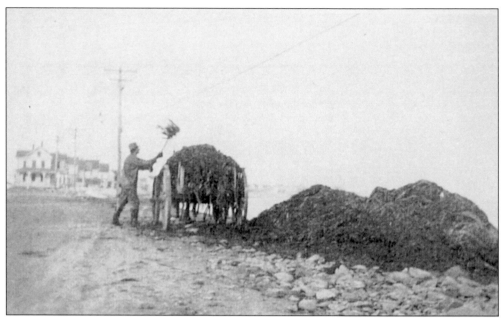

HARVESTING SEAWEED. Following a storm in January 1933, an unknown farmer fills his wagon. Seaweed was also called sea manure and was gathered to be used as fertilizer.

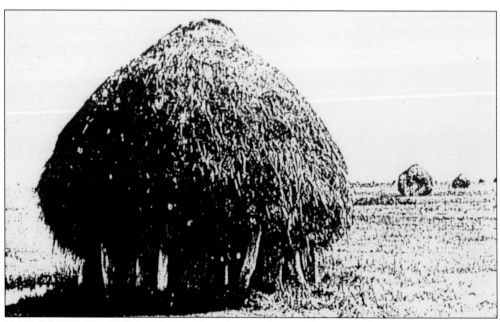

HAY COCKS ON THE MARSH. These hay cocks on pilings were built to store the hay for the winter. The pilings kept the hay off the ground and above the flood tides. The cone shape facilitated the shedding of water or snow. The outer layer of hay would spoil but the inside remained dry and usable for spring fodder.

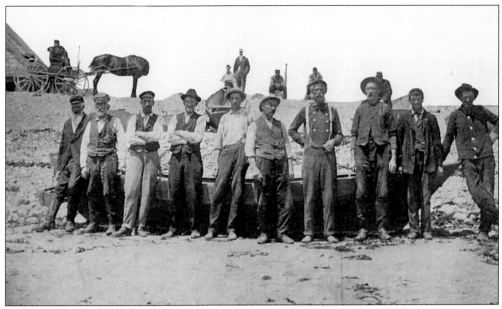

WELLS BEACH FISHERMEN. This c. 1900 photograph shows, from left to right: Langdon Welch, Christopher Eaton, George W. Moody, Will Stevens, Edward Watson, Leander Perkins, Alvin York, Sylvester Gray, Fred Studley, and James Flaker.

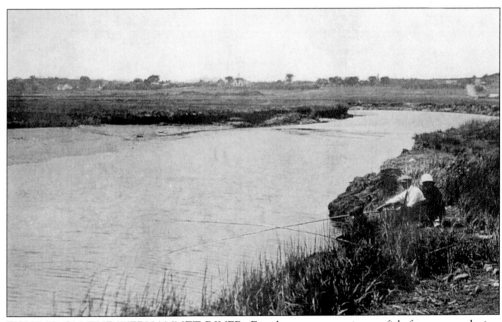

FISHING ON THE WEBHANNET RIVER. For those not wanting to fish from open dories, the catch at high tide along the Webhannet was often sufficient.

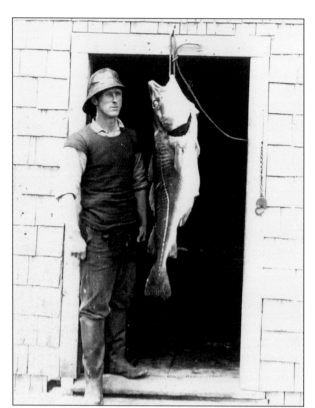

CATCH OF THE SEASON.
Wesley K. Moody poses with a 50-pound cod taken *c*. 1920.

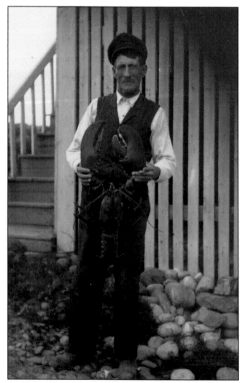

CATCH OF THE SEASON. Elmer Welch
poses with a 12-pound lobster in 1906.

FISHERMEN WITH SHARK.
George Prescott Moody and
his father, George W. Moody,
display the shark they landed,
c. 1920.

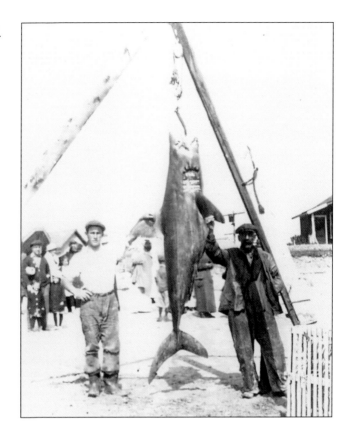

THE SALT WORKS AT MOODY POINT. During the Revolution salt could no longer be imported. Several locations in Wells utilized the rocky coast to collect salt from the sea water. Thirty bushels per week were derived from just one of these sites.

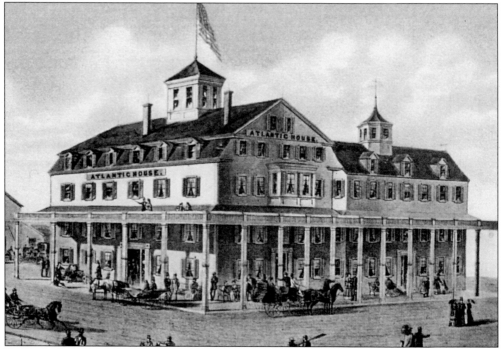

THE ATLANTIC HOUSE. Wealthy merchants from inland cities discovered the balmy summer breezes of the Atlantic here by the mid-1800s. This first large hotel was built in the 1850s at the Gold Ribbon Drive area at Wells Beach. John Horne from Berwick was the owner and proprietor. The hotel included a dance hall, billiard room, bowling alley, steam laundry, tennis courts, and livery stable. Wealthy guests would come for the whole summer season. The building burned on November 13, 1885.

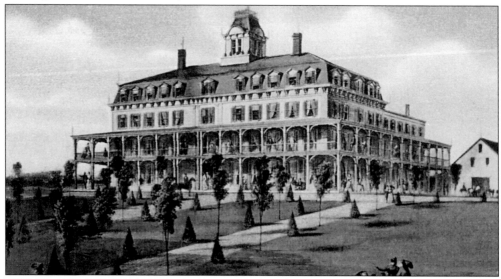

THE ISLAND LEDGE HOUSE. Built in 1872, this elegant lavishly furnished hotel had broad piazzas all around. Built by Harrison Davis of Somersworth, Alfred Davis of Worcester, and William Worster of Berwick, this complete entertainment center was considered one of the most attractive along the coast. It burned in 1877.